Interrupted Lives

Interrupted Lives
in Literature

Charles Nicholl

Richard Holmes

Andrew Motion

Patricia Duncker

Erica Wagner

Ali Smith

Edited by Andrew Motion

National Portrait Gallery, London

Published in Great Britain by National Portrait Gallery Publications,
National Portrait Gallery, St Martin's Place, London WC2H 0HE

For a complete catalogue of current publications please write to the
address above, or visit our website at www.npg.org.uk/publications

ISBN 1 85514 349 6

A catalogue record for this book is available from the British Library.

Publishing Manager: Celia Joicey
Editor: Susie Foster
Copy Editor: Johanna Stephenson
Design: Caroline and Roger Hillier, The Old Chapel Graphic Design
Production: Ruth Müller-Wirth
Printed in Belgium

The publisher would like to thank the copyright holders for granting
permission to reproduce works illustrated in this book. Every effort has
been made to contact the holders of copyright material, and any
omissions will be corrected in future editions if the publisher is notified
in writing.

Front cover: Sylvia Plath by Rollie McKenna, 1959 (detail)
Frontispiece: Katherine Mansfield by Lady Ottoline Morrell, 1916

Contents

Contributors

Charles Nicholl is the author of nine books, including *The Reckoning*, an investigation of the murder of Christopher Marlowe, and *Somebody Else*, a study of the poet Rimbaud. A regular newspaper contributor, he has written and presented two television documentaries for Channel 4, contributed to various BBC radio programmes, and has lectured around the world. His new book, published in October 2004, is a biography of Leonardo da Vinci.

Richard Holmes is Professor of Biographical Studies at the University of East Anglia and award-winning author of many books, including *Shelley: The Pursuit*, *Coleridge: Early Visions*, *Dr Johnson & Mr Savage* and *Coleridge: Darker Reflections*. Other books include *Footsteps: Adventures of a Romantic Biographer* and, more recently, *Sidetracks: Explorations of a Romantic Biographer*. He is a Fellow of the British Academy and was awarded an OBE in 1992.

Andrew Motion is Poet Laureate and Professor of Creative Writing at Royal Holloway College, University of London. He has written biographies of Larkin and Keats, and his most recent collection of poetry is *Public Property*.

Patricia Duncker is the author of three novels, *Hallucinating Foucault*, *James Miranda Barry* and *The Deadly Space Between*, as well as many literary essays and scholarly articles. She is Professor of Creative Writing at the University of East Anglia, but also spends time writing at her home in France.

Erica Wagner was born in New York. She is the author of two books, *Gravity: Stories* and *Ariel's Gift: Ted Hughes, Sylvia Plath and the Story of Birthday Letters*, and her short stories have been widely anthologised and broadcast. She is the Literary Editor of *The Times*, and lives in London.

Ali Smith was born in Inverness. She has published two novels, *Like* and *Hotel World*, and three collections of short stories, including most recently *The Whole Story and other stories*. She occasionally writes for the *Guardian Review*, the *Scotsman* and the *Times Literary Supplement*, and now lives in Cambridge.

Preface

The death of anyone in their early or mid years is a tragedy. Their potential is unrealised and friends and family are left not only bereft, but with the saddest sense of what might have been. Loss is combined with the imagination of what could have been achieved.

To focus on those whose lives were cut short may be thought to be morbid, but there is a positive collective purpose to these essays: to consider important writers from a different angle. By concentrating on six famous writers, from a range of periods and with a variety of literary styles, the book presents a unique opportunity to ask questions not only about what they would have produced had they lived longer, but also how their work might have been regarded, and how it might have affected others.

Finding different and significant angles from which to consider those who have made British culture and history is a central part of the National Portrait Gallery's work. A portrait is itself a means of understanding some of who someone was; but it can never be a complete view. Thomas Carlyle, one of the founding spirits of the institution, saw portraits as 'a small lighted candle by which the biographies could for the first time be read'. But however good the portrait is as a work of art, it can only ever give a glimpse of the person and their work. These essays offer another form of illumination.

We are enormously grateful to Andrew Motion who conceived the idea for the book and series of lectures held at the National Portrait Gallery, and who pursued the choice of subjects and writers with such energy, determination and care. I am also grateful to the Arts Council of England for giving financial support to the original presentations, and to the *Guardian* for providing the opportunity to publish parts of several of the essays. I would like to offer thanks to Stephen Allen and Jan Cullen for organising such a successful series of talks, to Lucy Ribeiro for ensuring that the talks were accessible to all, to Susie Foster for overseeing the book so ably, and to designers Caroline and Roger Hillier, as well as to the many other colleagues for bringing this idea to fruition. I hope that *Interrupted Lives* will live on, not only in the form of this book, but as a continuing series of talks in the Gallery's future programme.

Sandy Nairne
Director

Introduction

The idea for the lecture series 'Interrupted Lives' came to me while I was writing my short novel *The Invention of Dr Cake* (2003). In that book I imagined John Keats recovering from the illness which in fact killed him in Rome in 1821, returning to England to complete his training as a doctor, changing his name, and setting up his practice in rural north Essex. My purpose was not simply to fulfil and enjoy a literary fantasy ('what if ... ?'), but to shine light from a surprising angle onto Keats's actual life and work, and therefore to make us think differently about it. In particular, I hoped that by adding an extra dimension to real circumstances I would encourage his readers to test and re-evaluate the facts they had always accepted as 'the truth'.

Long before finishing the novel, I realised that I might have taken a similar approach to anyone who died young, and have hoped to reap some of the same rewards. I also knew that I was not especially interested in biographical speculation at any cost. Although most of us share a tendency to reflect on the losses entailed in an early death, we feel that our speculations are most rewarding when they are most responsive to probabilities of one kind or another. We want to know what 'really' might have happened more than we want to know simply what could have happened (which might include escaping the limits of mortal behaviour entirely).

Niall Ferguson writes well about this in the essay collection *Virtual History* (1997). 'There have been,' he says by way of introduction, 'two distinct kinds of counterfactual which have been used by historians: those which are essentially the products of imagination but (generally) lack an empirical basis; and those designed to test hypotheses by (supposedly) empirical means, which eschew imagination in favour of computation.' There's no doubt where his own loyalties lie. 'By narrowing down the historical alternatives to those which are *plausible*,' he says, '– and hence by replacing the enigma of "chance" with the calculation of probabilities – we solve the dilemma of choosing between a single deterministic past and an unmanageably infinite number of possible pasts.'

As I was brooding on these and other thoughts stirred up by Ferguson's book, Sandy Nairne took over as the new Director of the National Portrait Gallery in London. When we were talking one day about his plans to re-charge the lecture series hosted by the Gallery, he asked me whether I had any ideas. I told him about the soon-to-be-published *Dr Cake*, and how I thought it might be interesting to apply similar principles to a number of other writers. Whereupon he invited me to come up with a list of possible subjects and lecturers (ideally a list which covered a decent time-span, dealt with a fair spread of styles and forms, and could be illustrated with portraits from the Gallery's collections), and then to commission them.

I chose several of the lecturers because they have already written well on the people I was now asking them to reconsider: Richard Holmes on Percy Bysshe Shelley, Erica Wagner on Sylvia Plath, Charles Nicholl on Christopher Marlowe. (I commissioned myself to write about Edward Thomas, one of my favourite poets, about whom I first wrote in my graduate thesis.) The others – Ali Smith on Angela Carter and Patricia Duncker on Katherine Mansfield – I chose because I happened to know they had a special interest in or affinity for the subjects. The results were heard in the Gallery during the first part of 2004, and are now collected here.

In the first instance, I wrote the speakers a letter which set no very obvious limits, but did encourage them to talk about certain key themes: what did we lose by the early death of the people they were talking about; what might have happened to them, and what might they have written, had they lived for longer; how does their early death affect our reading of their work. As readers of this volume will see, the speakers responded to these questions in fascinatingly different ways (as I hoped they would). That is to say: although the essays are linked by a common mood of elegy, and a shared feeling of deprivation, they reflect a wide variety of biographical styles, and a broad range of responses to the question of how 'chance' might connect with the 'plausible'.

Holmes and Wagner both spend a good deal of time talking about the circumstances of their subjects' actual deaths, and concentrate on the ways in which these affected their subsequent reputations. My own treatment of Thomas (the most almost-fictional in the collection) spares him from the death he actually suffered, and allows him to live for another good many years. Ali Smith is comparatively restrained in her suggestions about what Carter might have gone on to write, but drenches her account of the existing œuvre with a sense of incompleteness and loss. Duncker and Nicholl combine an appreciation of actual circumstance, and of genuine influence, with more elaborate speculations.

All the essays here have suggestive things to say about the life and work of their subjects: their insights often have great specific value, and deepen our understanding of individual cases. But for all their differences of approach, they also form part of a larger discussion about biography itself. In the last quarter or so of the twentieth century, biography in Britain enjoyed a golden age. But as the century drew to a close, a number of biographers began asking questions about the orthodoxies of the form – challenging the appearance of objectivity, wondering how to extend the range of subjects beyond those people who happen to have left helpfully large archives, querying the reliability of facts. *Interrupted Lives* draws many of these questions together, and finds new ways of dramatising them. It is a collection that looks to the future of the form, while revitalising important elements of the tradition.

Andrew Motion

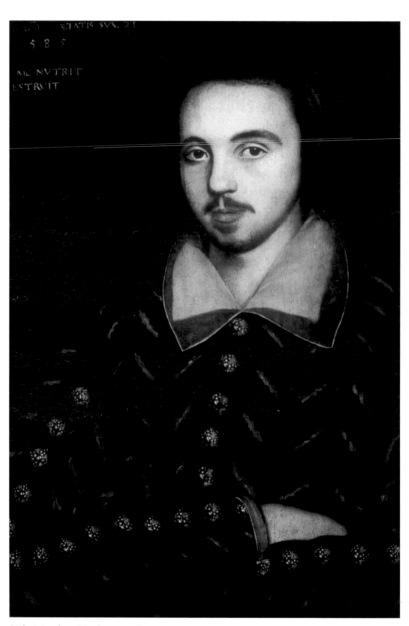

?Christopher Marlowe, 1564–93
Unknown artist, 1585
Oil on panel
Corpus Christi College, Cambridge

Christopher Marlowe
'Cut is the Branch'

Charles Nicholl

Christopher Marlowe was just twenty-nine years old when the thrust of a dagger brought him, as a contemporary put it, 'to a sudden & fearful end of his life'.[1] In our imagination of him, and even in our reading of him, he will always be a young man, wrapped in an aura of recklessness and confrontation which that last knife-fight seems to epitomize. This imagery of youthfulness is reinforced by the supposed portrait of him, discovered in Cambridge in the early 1950s. It shows a striking young man with long brown hair and a sardonic, slightly mocking expression; he wears a snazzy velvet doublet with golden buttons sewn along the sleeves. The motto inscribed in a corner of the painting seems somehow prophetic – *Quod me nutrit me destruit*: 'that which feeds me destroys me'. This young dandy may or may not be Marlowe but this is how we now see him.

It might be argued that twenty-nine was not as young for an Elizabethan as it is for us, but this does not lessen our sense of what was lost by his early death. Seven plays by him survive, as opposed to thirty-seven by Shakespeare. There comes this moment of violence, this 'sudden & fearful end', and the rest is silence. The year was 1593, a bad year for writers which also saw the arrest and imprisonment of two of Marlowe's colleagues, Thomas Kyd and Thomas Nashe, and the execution of three dissident religious pamphleteers, John Penry, Henry Barrow and John Greenwood. Marlowe was himself under surveillance. Less than two weeks before his death he was called in for questioning by the Privy Council. These were edgy times, and it was precisely at this dangerous edge where literature shaded into politics that Marlowe lived, and wrote, and died.

Of Marlowe's last day – Wednesday 30 May 1593 – we know a good deal from the coroner's inquest,[2] held some thirty-six hours after the event, though there is much we wish to know which the document does not tell us. He was killed in a house on or near the Thames, at Deptford Strand, on the south-eastern outskirts of London. He had spent the day there with three men, Ingram Frizer, Nicholas Skeres and Robert Poley; and he was fatally stabbed by Frizer that evening. The circumstances of the killing are often described as a 'tavern brawl', but neither of these words is really accurate. There is no evidence that the house was a tavern, though it may well have been a lodging-house; and the inquest makes it clear that Marlowe and his companions were 'alone together' in a room when the fatal 'affray'

occurred, making the event something more private, more closeted, than is conveyed by the word 'brawl'. It also means that the only witnesses of the killing were Messers Skeres and Poley, two men whose documented careers as spies and swindlers make their testimony unsatisfactory to say the least. According to the story they told the coroner, it happened like this. After supper, Frizer and Marlowe had a quarrel over the bill: they spoke 'divers malicious words' about 'the sum of pence owed' for the day's food and drink – the 'recknynge' or reckoning. Marlowe was lying on a bed; Frizer was sitting at a table with his back to him. (According to another account, gossipy but well-informed, Frizer was 'playing at tables' – in other words backgammon – with one of the others.[3]) 'Moved with anger', Marlowe leapt from the bed, snatched Frizer's dagger from its sheath, and struck him on the head, giving him two shallow flesh-wounds which were afterwards seen and punctiliously measured by the coroner. In the ensuing struggle the dagger was thrust straight into his face, the blade entering above his right eye, passing through the superior orbital fissure at the back of the eye-socket, and penetrating his brain to a depth of two inches; from this wound, as the inquest drily puts it, 'the said Christopher then and there instantly died'. Frizer claimed self-defence, as this story entitled him to, and received a royal pardon for the homicide four weeks later.

Thus casually, pointlessly, a writer of genius died in a back-room by the river. The casualness has of itself a certain grim Marlovian poetry but there are many other interpretations of what happened that evening, and of the strange web of circumstances which brought Marlowe to that house in Deptford, and to that twelvepenny dagger which recalls his own chilling lines about the conquering sword of Tamburlaine:

> There sits Death, there sits imperious Death,
> Keeping his circuit by the slicing edge.[4]

At the time of his death Marlowe was probably the most famous dramatist of his day – Shakespeare was still very much in his shadow; Kyd had run out of ideas; Ben Jonson was an unknown former bricklayer and soldier just beginning to get some bit-parts as an actor. The son of a Canterbury shoemaker, a scholarship boy at Cambridge, Marlowe left university in 1587 and immediately scored his first commercial success with *Tamburlaine the Great*, a remorseless tale of ambition and conquest based on the exploits of the fourteenth-century Tartar warlord, Timur-i-leng. He swiftly cobbled up a sequel, Hollywood-style, titled *The Second Part of the Bloody Conquests of Mighty Tamburlaine*. At a performance of the latter, by the Admiral's Men in November 1587, a 'caliver' or musket used onstage was accidentally loaded and killed two members of the audience, one of them a

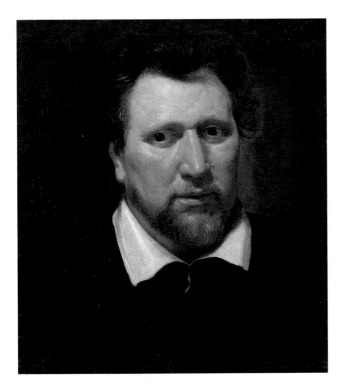

Ben Jonson, 1573?–1637
Abraham van Blyenberch,
c.1617
Oil on canvas,
470 x 419mm
(18½ x 16½")
National Portrait Gallery,
London (NPG 2752)

pregnant woman. An explosive new talent had arrived, and he remained at the forefront of theatrical popularity for the remaining six years of his life.

His work had an unparalleled impact. Another play which spilled off the stage was *Dr Faustus* (*c*.1588), with its archetypal story of the magician who pawns his soul to the devil in return for knowledge and power. The author Thomas Middleton recalled an early performance, at the Theatre in Shoreditch, when the wooden walls of the playhouse suddenly 'crackt' and 'frighted the audience'. More apocryphally, there was the story of a performance at Exeter, when the players suddenly stopped in the middle of a scene 'for they were all persuaded there was one devil too many amongst them'. On learning this the audience promptly fled – 'every man hastened to be first out of doors' – and the players spent the night in unaccustomed prayers. This is theatrical folklore but the upshot of these stories is pretty clear: *Faustus*, for its first audiences, was extremely scary.

To be accounted London's premier dramatist – or as the Elizabethans more bluntly put it, 'playmaker' – did not necessarily endear Marlowe to the authorities, or to the many citizens that heartily disapproved of plays. The first London playhouses were built outside the city walls, in the so-called 'liberties' beyond the

control of the Mayor and his aldermen. Their increasing commercial success was viewed as something of a civic nuisance – a potential for riotous assembly, for the transmission of plague, for prostitution and pickpocketing and apprentices behaving badly. They also had a potential for the spreading of dangerous ideas: a potential for disaffection and dissent. The playhouses were policed – they were frequently shut down, usually on health grounds – and plays had to be submitted to the censor. The manuscript of the play *Sir Thomas More*, written in the early 1590s, survives with the censor's annotation: 'Leave out the insurrection wholly & the cause thereof'.[5]

Nor was 'playmaker' by any means the worst of the words you might hear applied to Christopher Marlowe. His reputation was extremely lurid. The most frequent accusation levelled at him was that he was an atheist and blasphemer, who held and indeed broadcast 'monstruous opinions' about religion. Marlowe was accused of 'diabolical atheism', in print, by his literary rival Robert Greene,[6] but the *locus classicus* of Marlovian heresy is a grubby sheet of writings produced by a professional informer, Richard Baines, who claimed to have heard Marlowe say such heinous things as: 'Christ was a bastard and his mother dishonest', and 'the sacrament would have been much better being administered in a tobacco pipe', and 'Christ was bedfellow to St John and used him as the sinners of Sodoma'.[7] This last squib draws on another related heterodoxy, for Marlowe was also said to be (and most probably was) homosexual. Baines reports the famous gay quip – 'that all they that love not tobacco and boyes were fools' – the phrasing of which is so good that one feels that, in this instance at least, Baines is recording authentic Marlowe talk. Baines concludes his report by suggesting that 'the mouth of so dangerous a member' should be 'stopped' – a recommendation made more sinister by the fact that Baines's note was handed to the authorites just three days before the fatal stabbing of Marlowe at Deptford.

We hear of other allegations about his disorderly opinions – that he was a malcontent Catholic intending to 'go to the enemy'; that he was a dabbler in magic. And we hear of his actual run-ins with the law. In a single year, 1592, he was arrested three times – once in Flushing, in the Netherlands, whence he was deported on a charge of counterfeiting coins; once in Shoreditch, where he was bound over to keep the peace towards the constable and beadle of Holywell Street; and once in Canterbury, when he fought in the streets with a tailor named Corkine, his weapons being a staff and a dagger.

And, floating among these allegations and rendering many of them more complex, we learn that he was a spy of some sort – an intelligencer or 'projector', a meddler in secret politics. While the 'Baines Note' is dubious as a record of Marlowe's religious views, it is one of many documents which open up this habitat in which Marlowe moved – that shady world of informers and intelligencers which

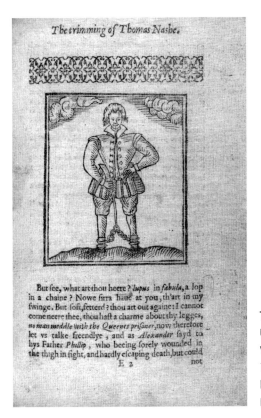

The trimming of Thomas Nashe.

But fee, what art thou heere? *lupus* in *fabula*, a lop in a chaine? Nowe firra haue at you, th'art in my fwinge. But foft, fetterd? thou art out againe: I cannot come neere thee, thou haft a charme about thy legges, *no man meddle with the Queenes prifoner*, now therefore let vs talke freendlye, and as *Alexander* fayd to hys Father *Phillip*, who beeing forely wounded in the thigh in fight, and hardly efcaping death, but could
E 2 not

Thomas Nashe, 1567–1601
Unknown engraver, 1597
Woodcut from
The Trimming of Thomas Nashe
by Richard Lichfield, 1597
British Library

was such a feature of late Elizabethan politics. As early as 1587 the Privy Council commended him for his 'faithful dealing' in certain unspecified 'affairs', and defended him from rumours that he was about to defect to the English Catholic seminary at Rheims. His presence in the war-torn Netherlands in 1592 was probably also in an intelligence connection; his 'chamber-fellow' there was the spy Richard Baines who a year later denounced him as an atheist.

This atmosphere of secret politics seeps into that little room at Deptford, where Marlowe died in a huddle of spies – a victim, though not perhaps an innocent victim, of that world of tawdry intrigue, of political masters and their 'climbing followers', which he mirrors in plays like *The Jew of Malta*, first performed at the Rose theatre in February 1592, a few weeks after his ignominious departure from the Netherlands.

When he died his fellow-writers paid tribute to his huge powers as a poet. George Peele called him 'the Muses' darling', a poet 'fit to write passions'.[8] Nashe compared him to the Italian satirist Aretino: 'his pen was sharp-pointed like a

William Shakespeare,
1564–1616
Attributed to John Taylor,
c.1610
Oil on canvas, 552 x
438mm (21¾ x 17¼")
National Portrait Gallery,
London (NPG 1)

poignard; no leaf he wrote on but was like a burning-glass to set on fire all his readers'.[9] Shakespeare paid him a kind of tribute in *As You Like It* (1598–9), when Rosalind quotes a famous line from Marlowe's *Hero and Leander* (published in 1598), and praises the 'dead shepherd' who wrote it: it is the only occasion when Shakespeare openly quotes, rather than quietly filching, a line by a contemporary writer. (In the same play Shakespeare gives the clown Touchstone a riddling line – 'It strikes a man more dead than a great reckoning in a little room' – which is interpreted by many as a reference to the killing of Marlowe.[10]) Perhaps the loveliest epitaph is Michael Drayton's, who calls him 'neat Marlowe' – neat as in a shot of whisky – and says he

> Had in him those brave translunary things
> That the first poets had; his raptures were
> All air and fire ...[11]

These are fine words but they cannot be called representative. Many were glad to see Marlowe's violent end as a sign of God's judgement on him and his scandalous lifestyle. 'See what a hook the Lord put in the nostrils of this barking dog', wrote a young Puritan preacher named Thomas Beard (who was later schoolmaster to Oliver Cromwell).[12] Marlowe was reviled as much as he was revered, and his reputation is probably summed up more accurately by the anonymous author of a college comedy, the *Return from Parnassus*, performed at Cambridge around Christmas 1601, who said of him:

> Pity it is that wit so ill should dwell:
> Wit lent from heaven but vices sent from hell.[13]

The terminology is simplistic, but he is surely right that if Marlowe was famous for his 'wit' – in the Elizabethan sense of intellectual brilliance – he was no less notorious for his 'vices'.

Marlowe's police record identifies him as a 'disturber of the peace', and this is true also of his plays, which disturb the peaceful complacencies of orthodoxy and faith. Part of their charge is the way he gives such poetic and intellectual charisma to characters he ought to be condemning. Their overt message seems conventional, even reactionary, but is laced with subliminal ambiguitues like cross-currents beneath the surface. This is already notable in *Dr Faustus* (in my view an early play, *c.*1588, though there are other views) which promises and delivers the message of damnation, yet conveys also a rhapsodic sense of mental adventure and liberation which is stronger than the punishment. This toying with expectations is even more marked in later plays such as *The Massacre at Paris* (*c.*1593), a bleak reportage of the events surrounding the St Bartholomew's Day massacre of Protestants in 1572, in which the fanatical Duke of Guise – the perpetrator of the outrage, the Osama bin Laden of Elizabethan Protestantism – is another of Marlowe's disturbingly charismatic villains with all the best lines:

> Oft have I levelled and at last have learned
> That peril is the chiefest way to happiness ...

The poetry here has that spare, sardonic, hard-boiled style which is the mark of Marlowe's mature work, as in this cynical card-sharping metaphor for the seizure of political power –

> ... Then Guise,
> Since thou hast all the cards within thy hands

To shuffle or cut, take this as surest thing:
That right or wrong thou deal thyself a king.[14]

Another bogeyman given centre stage is 'old Machevill' or Machiavelli, the controversial political philosopher whose works were still, sixty years after his death, banned in England. His appearance as the prologue to *The Jew of Malta* (*c*.1591) proclaims not only that the eponymous hero is a 'Machiavellian' in the conventionally disparaging sense of a greedy schemer, but also trails a provocative parallel between this banned purveyor of unpalatable truths and Marlowe himself:

To some perhaps my name is odious,
But such as love me guard me from their tongues,
And let them know that I am Machevill,
And weigh not men and therefore not men's words.
Admired I am of them that hate me most:
Though some speak openly against my books
Yet will they read me ...
I count Religion but a childish toy
And hold there is no sin but ignorance.[15]

As Stephen Greenblatt observes, Marlowe is the antithesis of Spenser – they are 'mighty opposites' in the ongoing Elizabethan debate on the poet's role within society. Spenser sees 'identity as conferred by loving service to legitimate authority, to the yoked power of God and the State', but for Marlowe identity is precisely 'established at those moments in which order is violated'.[16] Or as David Riggs, author of a splendid new biography, puts it: 'what does his story reveal about the relationship between literary achievement and moral truancy'?[17]

When a writer dies so young it is inevitable that one wonders: what if things had been different, and he had survived? Where would his life and writings have gone? It is hard to imagine Marlowe getting old, making the transition – in the famous phrasing of Shakespeare's 'seven ages of man' speech – from that combustible young man, 'muttering strange oaths' and 'sudden and quick in quarrel', to the more upright self-certainties of middle age –

With eyes severe, and beard of formal cut,
Full of wise saws and modern instances

– let alone arriving at the 'lean and slippered pantaloon' of dotage.[18]

But it is more than a matter of being hard to imagine. As those critics I quote above have suggested, Marlowe's whole career was bound up with confrontation, with the violation of rules, with 'moral truancy'. His dissident views (no doubt exaggerated by Baines and others though not essentially invented by them) had put him on a collision course with the Elizabethan state, a nervous, authoritarian government at war with Catholic forces in Europe and subversive elements at home. The gallows were busy in these years; the political prisons − the Tower, the Marshalsea, the gulag of Wisbech Castle − were full to bursting. This is the chilling thing about his death at Deptford: it enacts with seeming randomness a destruction, a silencing, which was already politically inevitable. He was already trapped in that 'little room', with no door out.

Somewhat ironically there is a small but vocal minority of Marlowe enthusiasts who insist that he *did* survive that day, that he was spirited away from the scene by his political protectors, that the body viewed by the coroner and his jurors was somebody else's (a drunken sailor from the Deptford dockyards is usually recruited for this unhappy role.) This improbable scenario is in turn the foundation for the certifiably daft idea that Marlowe thereafter devoted his life to writing the plays and poems generally ascribed to Shakespeare. The earliest proponent of this theory was an American lawyer, Wilbur Ziegler, who published a novel in 1895 called *It was Marlowe*; and the most famous and tenacious was the Canadian scholar Calvin Hoffman, who believed that Marlowe's patron Thomas Walsingham (a younger cousin of the spymaster Sir Francis) had organized his escape, and that evidence of this would be found in the Walsingham family vault in Chislehurst church. He got permission to open the vault in 1956 but predictably found nothing.

The current keepers of this flame are a fundamentalist sect based in Kent known as the Marlowe Society. A couple of years ago, when Marlowe was belatedly commemorated with a stained glass window in Poets' Corner at Westminster Abbey, the Society lobbied for a question mark to be added to his death-date of 1593, and someone at the Abbey was weak-minded enough to agree. The documentary evidence of Marlowe's death is considerable; the documentary evidence of his survival non-existent. The question mark is not really a question at all, but an expression of blind faith: because Marlowe wrote the plays of Shakespeare he could not have died in 1593. Michael Frohnsdorff of the Marlowe Society claims to have evidence that Marlowe was alive in 1613, but short of producing the actual false whiskers Marlowe wore while writing *Hamlet* I suspect it will add little to this non-existent argument.

'Cut is the branch that might have grown full straight,' says the Chorus dolefully at the end of *Dr Faustus*.[19] The heretical scholar 'who practised more than heavenly power permits' has arrived at the inevitable destined moment of damnation. His

soul has been carried off to Hell – a fate which many predicted for the author himself – leaving his 'mangled' body 'all torn asunder' by the devils with whom he had illicitly trafficked.

The phrase is often used, for obvious reasons, about Marlowe himself. But would he have 'grown full straight'? Or does his greatness lie precisely in his lack of straightness, his scorn of the respectable, his questioning of established beliefs? What Marlowe 'might have been' can in the end only be predicated on what he already was, and on that question posterity is still battling to find an answer. Heavenly wit or hellish vices, the Muses' darling or the barking dog, the government's man or the renegade rule-breaker – which, if any, is the real Christopher Marlowe? Ambiguity was the element he lived in, belonging to both sides and to neither, and finding thereby a kind of freedom from the harshly enforced certainties of the time. 'That like I best', he wrote, 'that flies beyond my reach ...'[20]

Notes

1 Sir John Puckering, c. June 1593, annotations on the scribal copy of the 'Baines Note' (see note 7 below).

2 Public Record Office, C260/174, no. 27; transcribed in Leslie Hotson, *The Death of Christopher Marlowe* (Cambridge, Mass., 1925), pp.28–34.

3 William Vaughan, *The Golden Grove Moralized* (London, 1600), sig. c4v–c5.

4 Christopher Marlowe, *1 Tamburlaine*, 5.1, 111–12, in *Complete Works*, ed. Fredson Bowers (Cambridge, 1981), Vol.1, p.135.

5 The play survives in a fragmentary manuscript (British Library, Harley MS 7368), written in various hands of which one ('Hand D') is thought to be Shakespeare's. The injunctions of the censor (Sir Edmund Tilney, Master of the Revels) are written down the left-hand margin of the opening scene (fol. 3r); he warns the authors to comply exactly with his orders, '& not otherwise at your own perils'. See *The Book of Sir Thomas More*, ed. F.P. Wilson (Oxford, 1961), p.1.

6 Robert Greene, *Greene's Groatsworth of Wit* (London, 1592), sig. F1, in *Complete Works*, ed. Alexander Grosart (London, 1881–6), Vol.12, p.141.

7 Richard Baines, 'A note containing the opinion of one Christopher Marly' (British Library, Harley MS 6848, fols. 185r–186r). This is the original report, in Baines's hand; there is also a scribal copy, prepared for 'Her H' (i.e. Queen Elizabeth), with annotations by Sir John Puckering (Harley MS 6853, fols. 307r–308r).

8 George Peele, *The Honour of the Garter* (London, 1593), 57–63, in *Life and Works*, ed. Charles T. Prouty (Newhaven, Conn., 1952), Vol.1, p.245.

9 Thomas Nashe, *The Unfortunate Traveller* (London, 1594), sig. F4, in *Works*, ed. R.B. McKerrow and F.P. Wilson (Oxford, 1958), Vol.2, p.264.

10 William Shakespeare, *As You Like It*, 3:5, 82–3; 3:3, 11–12; in *The Complete Oxford Shakespeare*, eds. Stanley Wells and Gary Taylor (Oxford, 1987), Vol. 2, pp.708, 706.

11 Michael Drayton, *Of Poets and Poesy* (London, 1627), p.25.

12 Thomas Beard, *The Theatre of God's Judgements* (London, 1597), pp.147–8.

13 Anon, 'The progress to Parnassus' (Folger Library, Washington, DC, MS V/a/355, fol. 7r); see *The Three Parnassus Plays*, ed. J.B. Leishman (London, 1949).

14 Christopher Marlowe, *The Massacre at Paris*, scene 2, 94–5, 145–8, in *Complete Works*, Vol.1, pp.366–7.

15 Ibid., *The Jew of Malta*, Prologue 5–11, in *Complete Works*, Vol.1, p.263.

16 Stephen Greenblatt, *Renaissance Self-fashioning* (Chicago, 1980), p.222.

17 David Riggs, 'Marlowe's Quarrel with God', in *Marlowe, History and Sexuality*, ed. Paul Whitfield White (New York, 1998), p.19.

18 William Shakespeare, *As You Like It*, 2:7, 139–66, in *Oxford Shakespeare*, Vol. 2, p.701.

19 Christopher Marlowe, *Dr Faustus*, 5:3, 19, in *Complete Works*, Vol. 2, p.228.

20 Ibid., *The Massacre at Paris*, scene 2, 99, in *Complete Works*, Vol. 1, p.366.

CHRISTOPHER MARLOWE: A CHRONOLOGY

1564 26 February Baptism of Christopher Marlowe at St George's Canterbury.

1573 Christopher 'Mowle', possibly Marlowe, working in a Canterbury 'victualling house'.

1578 Pupil at King's School, Canterbury.

1580 Enters Corpus Christi College, Cambridge, as a Parker scholar.

1584 Graduates BA.

1585 Portrait of a young man believed to be Marlowe painted.

1585–7 Probable composition of *Dido Queen of Carthage*, and translations of Ovid and Lucan.

1587 June Rumours of Marlowe's Catholic sympathies scotched by Privy Council.

 July Marlowe graduates MA.

Both parts of *Tamburlaine* performed in London before the end of the year.

1588–9 Composition and first performance of *Dr Faustus* [?].

1589 September Arrested after a streetfight in Shoreditch.

1590 Publication of *Tamburlaine* (the only play published during his lifetime).

1591 Sharing a chamber with playwright Thomas Kyd. Writes *The Jew of Malta* [?].

1592 January Arrested in the Netherlands on charges of counterfeiting.

 February First recorded performance of the *Jew* at the Rose theatre.

 May Bound over to keep the peace towards the constables of Shoreditch.

1593 January First recorded performance of *Massacre at Paris*.

 May Living with Thomas Walsingham at Scadbury, near Chislehurst, perhaps writing *Hero and Leander*.

 12 May Discovery in Kyd's lodgings of 'hereticall' writings said by Kyd to be Marlowe's.

 18 May Warrant issued for the apprehension of Marlowe.

 20 May Appears before Privy Council; ordered to report to them daily.

 27 May The 'Baines Note' listing Marlowe's blasphemies delivered to the authorities.

 30 May Fatally stabbed by Ingram Frizer.

 1 June Post-mortem inquest, and burial at St Nicholas's, Deptford.

 28 June Ingram Frizer receives royal pardon.

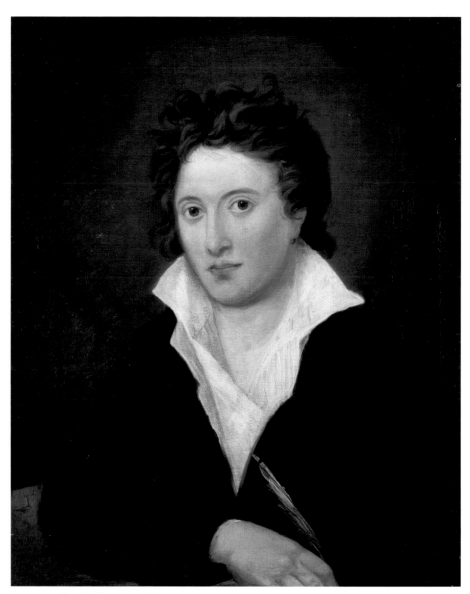

Percy Bysshe Shelley, 1792–1822
Amelia Curran, 1819
Oil on canvas, 597 x 476mm (23½ x 18¾")
National Portrait Gallery, London (NPG 1234)

Shelley Undrowned

Richard Holmes

In the summer of 1822, the *Courier*, a leading Tory newspaper in London, carried a brief obituary that began: 'Shelley, the writer of some infidel poetry, has been drowned: now he knows whether there is a God or no.' From this moment on, the dramatic death of Percy Bysshe Shelley in the Gulf of Spezia was set to become one of the most powerful of all Romantic legends. And also perhaps the most misleading.

Shelley drowned in his own sailing boat, the *Don Juan*, while returning from Livorno to Lerici in the late afternoon of 8 July 1822, during a violent summer storm. He was a month short of his thirtieth birthday. Like Keats's death in Rome the year before, or Byron's death at Missolonghi two years later, this sudden tragedy set a kind of sacred (or profane) seal upon his reputation as a youthful, sacrificial genius. But far more comprehensively than theirs, Shelley's death was used to define an entire life, to frame a complete biography. It produced not hagiography, but thanatography.

Through an astonishing array of pictures, poems, inscriptions, memoirs and Victorian monuments, this death spun a particular image of Shelley's character more effectively than any modern PR campaign. It projected a writer who was unearthly, impractical and doomed. In Matthew Arnold's notorious summation, Shelley was 'a beautiful and ineffectual angel, beating in the void his luminous wings in vain'.[1] Shelley could always fly, but he could never swim.

The legend of his death transformed his life almost beyond recovery. Here, for instance, is what was inscribed (in Italian) on the wall of his last house, the skull-like Casa Magni, with its five gaping white arches and open terrace, gazing out to sea at San Terenzo, on the bay of Lerici:

> Upon this terrace, once protected by the shadow of an ancient oak-tree, in July 1822, Mary Shelley and Jane Williams awaited with weeping anxiety the return of Percy Bysshe Shelley, who, sailing from Livorno in his fragile craft, had come to shore by sudden chance among the silences of the Elysian Isles. – O blessed shores, where Love, Liberty and Dreams have no chains.

This unearthly legend had been built up steadily throughout the nineteenth century. Shelley's wife Mary herself launched it, writing immediately after his death: 'I was never the Eve of any Paradise, but a human creature blessed by an elemental

spirit's company & love – an angel who imprisoned in flesh could not adapt himself to his clay shrine & so has flown and left it.'[2]

Shelley's friend and champion, the incorrigible myth-making Edward John Trelawny, set the metamorphosis literally in stone. His inscription for the tablet above Shelley's ashes in the Protestant Cemetery at Rome was taken from *The Tempest*:

> Nothing of him that doth fade
> But doth suffer a sea change
> Into something rich and strange.

This inscription gathered its own irony. In his journal for 1822, Trelawny had written a simple graphic description of the seasonal storm that had overwhelmed Shelley's boat, and the cremation of Shelley's body on the beach at Viareggio, which Trelawny had brilliantly stage-managed as a pagan ceremony, with libations of wine, oil and spices. But he obsessively rewrote his account nearly a dozen times over the next fifty years, accumulating more and more baroque details, like some sinister biographical coral-reef. He raised the possibility that Shelley's boat had been rammed or, alternatively, that Shelley had been suicidally unseamanlike. 'Death's demon,' he intoned delphically in his *Records of Shelley, Byron, and the Author*, a final version published in 1878, 'always attended the Poet upon the water.'

By 1889 Louis Fournier's celebrated painting *The Cremation of Shelley* (now in the Walker Art Gallery, Liverpool) showed a miraculously undamaged corpse offered up to Heaven on a martyr's pyre, with Trelawny and Byron striking solemn Romantic poses (actually they went swimming), and a pious Mary kneeling on the windswept beach in floods of tears (although in fact she was never there at all).

The myths became funereal monuments. A marble tomb commissioned by the Shelley family from Horatio Weekes (1854) was based on an Italian *pietà*, with Shelley's Christ-like body lovingly cradled in Madonna Mary's arms. Forty years later, another monument by E. Onslow Ford, paid for by the Shelley Society, was installed in University College, Oxford. It shows a white, supine Shelley draped like a fallen angel across a green sacrificial altar, with a weeping sea nymph below the plinth. It is now protected by iron bars.

Such mythic echoes are still resonant. Germaine Greer in her recent study *The Boy* (2003) relates Shelley's death to the tradition of the beautiful vulnerable male, linking him to the classical death of Bion, the erotic drowning of Leander, and the masochistic martyrdom of St Sebastian.

So Shelley's whole life, in retrospect, seemed to be fleeting, angelic, ephemeral, and doomed. It was a natural extension to suggest that it was also probably suicidal,

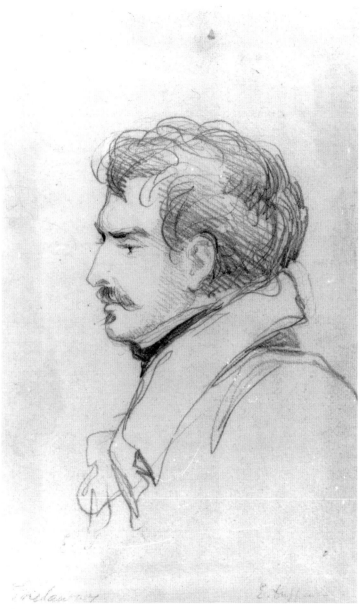

Edward John Trelawny, 1792–1881
Bryan Edward Duppa
Pencil, 102 x 89mm (4 x 3½")
National Portrait Gallery, London (NPG 2882)

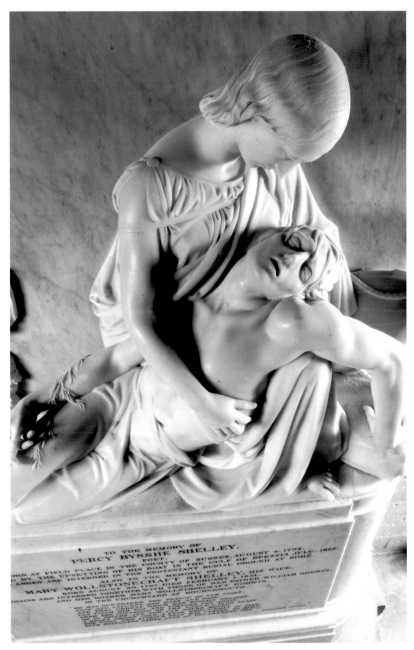

Memorial to the drowned Shelley in Christchurch Priory, Dorset
Horatio Weekes, 1854

or contained unmistakable prophesies of his own death. Again it was Mary who was the first to pick out this theme. She wrote in her 'Note to the Poems of 1822' of how Shelley had: 'as it now seems, almost anticipated his own destiny and, when the mind figures his skiff wrapped from sight by the thunder-storm, as it was last seen upon the purple sea, and then, as the cloud of the tempest passed away, no sign remained of where it had been – who [would not] regard as a prophesy the last stanza of the 'Adonais' (1821)?'

> The breath whose might I have invoked in song
> Descends on me; my spirit's bark is driven,
> Far from the shore, far from the trembling throng
> Whose sails were never to the Tempest given;
> The massy earth and sphered skies are riven!
> I am borne darkly, fearfully, afar;
> Whilst, burning through the inmost veil of Heaven,
> The soul of Adonais, like a star,
> Beacons from the abode where the Eternal are.

The shadow of prophesy, the sense of 'fatal destiny' subtly shaped the way his work was selected and read. He was a cloud, a skylark, a hectic leaf blown before the wild west wind. Boats and storms become evident everywhere in his poems, from the tiny skiff driven through the 'boiling torrents' described in 'Alastor' (1816) to the battered vessel swamped by 'a chaos of stars' in 'A Vision of the Sea' (1820).

The nightmare imagery of his last unfinished poem, 'The Triumph of Life' (1822), seemed to set a seal upon metaphysical despair. An enormous Chariot of Death advances like a huge storm-wave, engulfing the whole of human history, all youth and idealism:

> So came a chariot on the silent storm
> Of its own rushing splendour, and a Shape
> So sate within, as one whom years deform ...

From the earliest references to his childhood love of paper boats (often made of large denomination banknotes) to his last Faustian letters from the unearthly beauty of the bay of Lerici, these intimations of death seem to extend everywhere.

> My boat is swift and beautiful, and appears quite a vessel ... We drive along this delightful bay in the evening wind, under the summer moon, until earth appears another world ... If the past and the future could be obliterated, the present

would content me so well that I could say with Faust to the passing moment, 'Remain thou, thou art so beautiful'.[3]

Biography is caught and frozen, so to speak, in the glamorous headlights of Shelley's death. But if we set that death aside, if we switch off its hypnotic dazzle for a moment, maybe quite different patterns and trajectories can emerge from Shelley's life.

First of all, the circumstances of his drowning can be shown to involve prosaic bad luck, and bad judgement, as much as ill-starred destiny. Despite what Trelawny implied, Shelley had considerable previous experience with sailing boats, from schoolboy expeditions up the Thames to sailing single-handed (or with his ex-Royal Navy friend Edward Williams) down the Arno, the Serchio, and beyond Livorno harbour out to sea. He had successfully survived perilous incidents on the Rhine (with Mary) in 1814, on Lake Geneva (with Byron) in 1816, and on the Pisan Canal (with Williams) in 1821. Mary always recognised his 'passion' for boating, encouraged it as exercise, and observed that 'much of his life was spent on the water'. His courage and coolness afloat was also remarked on by Byron.

It was true, however, that Shelley was a river sailor. The *Don Juan* was his first ocean-going boat, although it was not the 'skiff' or 'fragile craft' of legend. It was a heavy 24-ft wooden sailing boat, based, according to Williams, on a scaled-down model of an American schooner (12m reduced to 8m). It had a lot of canvas: twin masts carrying main and mizzen sails, and a bowsprit flying three jibs. It was sleek, fast, with little sheer and, most significantly, no decking. Yet because of its unusual weight of sail it had to be heavily ballasted with 'two tonnes' of pig iron. It cost Shelley £80, or about one-tenth of his annual income. The local Italians were impressed with it, and even the Lerici harbourmaster, Signor Maglian, sailed with them in the open sea as far as Massa, in rough weather conditions.

The *Don Juan* had been delivered to Lerici on 16 May 1822, 'a perfect plaything for the summer'. After trials mostly spent racing Italian *feluccas* ('she passes the small ones as a comet might pass the dullest planets of the Heavens'), the boat was refitted by its designer, Captain Roberts, helped by Williams, in the last days of June. The aim was clearly speed. Adaptations included two new topmast sails (gaff topsails), an extended prow and bowsprit, and a false stern. In some accounts Williams also included shelves for Shelley's books inside the gunwales, a sporting concession.

But unknown to Shelley, the *Don Juan* had a fundamental design fault. A twin-masted schooner could not simply be scaled down to a small, undecked open boat. The sail to hull ratio was far too high, it was ballasted with too much pig iron, and it floated with too little freeboard. It was 'very crank' and dangerously unseaworthy. The refit, which they all thought so handsome, appears to have exaggerated all these defects: more sail, more ballast, less clearance. As it was undecked and carried

no buoyancy aids, the *Don Juan* was now in danger not simply of capsizing, but of foundering. In heavy seas it might fill with water from the stern or leeward side, and go straight down. It had become a nautical death trap.

Shelley set sail for Livorno, approximately 45 miles south, on 1 July 1822. Mary, who was ill and depressed, did not wish him to go. But the trip was neither solitary nor suicidal in intent. On the contrary, it was full of hope and high spirits: it was made to greet his old friend Leigh Hunt, who had just arrived in Italy to found a new literary journal. Four of them (including Captain Roberts) made the outward leg, very fast, in perfect weather conditions.

On the return trip there were only three aboard: Shelley, Williams and Charles Vivian, an English boatboy aged eighteen. It was intended as a single, fast seven-hour reach to Lerici, under their full glorious spread of canvas, to race them home by dusk. Mary and Jane Williams were waiting impatiently at the Casa Magni for their men. But now their luck ran out. After three hours a violent squall came up from the west. They had started too late to outdistance it. Trelawny had intended to accompany them in Byron's full-size schooner the *Bolivar*, but at the last moment was prevented by Italian port authorities. Had he been alongside, he would undoubtedly have saved them.

The *Don Juan*'s final moments are still disputed. Later, rumours of a pirate ramming, fostered by Roberts and Trelawny (both carrying an uneasy sense of blame), evaporate on examination. But there are persistent reports of a failure to take down the new gaff topsails (which required Vivian to climb the masts), or to reef the mainsails in time. They were clearly undermanned, but still attempting to run for home. The unseaworthy *Don Juan* was engulfed in enormous waves, had its false stern and rudder ripped off, lost both masts, and foundered in 10 fathoms of water about 15 miles off Viareggio. These details became clear when the wreck was salvaged by Italian fishermen two months later. It did not capsize and was not looted, as books, papers, wine bottles, a telescope (broken), a cash bag, some teaspoons and a sea trunk were all found lying within the open hull when it was pulled from the seabed. They were half-entombed in blue mud.

The boat went down so quickly that Williams did not have time to kick off his boots, and Shelley thrust a new copy of Keats's poems into his jacket pocket, so hard that it doubled back and the spine split. This much was clear (but not much else) from the three bodies cast up along the coast ten days later: they could be identified by their clothes, but not by their faces. There might have been one last chance. Williams had constructed an 8-ft coracle or dinghy, made of reeds and canvas, which was used as the *Don Juan*'s 'pram' or tender, and towed behind the boat. Shelley had frequently used this cockleshell for exploring Lerici Bay, and had so often capsized it in the surf that it is difficult to believe he hadn't at least learned to

doggy paddle. This dinghy was the one thing that remained afloat after the shipwreck, and was soon washed up on Viareggio beach. So the troubling question arises: did Williams (or Vivian) cut it loose? Did they (the good swimmers) attempt to push Shelley on to its upturned hull? Or did Shelley (the bad swimmer) gallantly resign it to them? These are haunting images of a different kind.

With better luck, or less gallantry, Shelley could well have survived. But did he also have reason to survive? He sometimes claimed to have abandoned writing, overwhelmed by Byron's aristocratic self-confidence and continuing literary success. 'I do not write – I have lived too long near Lord Byron & the sun has extinguished the glow-worm.' But actually Shelley had a huge amount of work in hand. He had written over 180 stanzas of 'The Triumph of Life' by the end of June, and its last lines – 'Then what is Life? I cried' – herald a continuing vision. He had started a political verse play about Charles I and the struggle for a republican England, featuring both Cromwell and Hampden. He had begun an erotic drama, *The Indian Enchantress*. He was working on major verse translations from Goethe and Calderon. He was writing many beautiful lyrics and songs, though, significantly, they were addressed to Jane Williams and not to Mary.

Nor had he abandoned his fundamental radicalism. He still thought of himself as 'atheist, democrat, philanthropist' – the provocative self-description he had entered in the hotel registers in Switzerland under 'occupation' long ago in 1816. His remarkable but little-known essay, 'A Philosophical View of Reform', written in 1820 (but not published for a century), promulgates universal suffrage, radical reform of the Houses of Parliament, women's rights, disestablishment of the Anglican Church, formation of trade unions, and reform of marriage laws and conventions (including the promotion of contraception). It was here he first declared that 'poets and philosophers' were the unacknowledged legislators of mankind.

Shelley greeted the new liberation movements throughout Europe (in Spain, southern Italy, Greece) with enthusiasm and celebrated them with odes to Liberty. When the Greek war of independence was declared in 1821, he immediately wrote his verse drama *Hellas* to salute it. In his Preface he announced triumphantly: 'We are all Greeks', and described his vision of an entire generation of young men, 'the flower of their youth, returning from the universities of Italy, Germany, and France', flocking to assist it. The choruses he composed were apocalyptic with hope, not despair:

> The world's great age begins anew,
> The golden years return,
> The earth doth like a snake renew

Her winter weeds outworn:
Heaven smiles, and faiths and empires gleam,
Like wrecks of a dissolving dream.

Above all, Shelley now had the scheme for the new journal, *The Liberal: Verse and Prose from the South*. The original title was 'Hesperides', and it was set to be the great literary mouthpiece of Romantic opposition. It was to be managed by Leigh Hunt, the leading liberal newspaper editor of the day, and printed in England by his brother John Hunt. As editor and printer of the *Examiner*, both men had gone to prison for seditious libel, and were ready for a fight. Hunt was to be financed by Byron and Shelley, his main contributors, producing a combination of talent that was deliberately intended to outrage Tory opinion. Other contributors were to include Mary Shelley and William Hazlitt. Four issues did eventually appear between October 1822 and July 1823. They carried Shelley's superb translation from *Faust*, Byron's scathing 'Vision of Judgement', Mary's intriguing short story 'The Bride of Modern Italy', and one of Hazlitt's finest essays, 'My First Acquaintance with Poets'. It was an astonishing constellation of talents, promising a new instalment of Romantic history. It was dissolved only by Shelley's death.

Such a reflection makes us look into the underlying patterns of his life, or its trajectories. It also raises some subtle questions about the nature of biography itself, and what we can learn from the notion of an alternative biography – or counter-factual history. If Shelley had indeed survived the shipwreck, how might his life have continued?

In 1821 Mary still treasured a dream of going to live with Shelley and their one surviving child (Percy Florence) on a Greek island, after the war of independence. 'If Greece be free, Shelley and I have vowed to go, perhaps to settle there, in one of those beautiful islands where earth, ocean and sky form the Paradise.'[4] There is a touching hint of Club Med in this fantasy, but practical and domestic considerations would surely have intervened. Certainly they would never have embarked (like the freebooting Trelawny) under Byron's banner.

It seems inevitable that at some point they would have returned to England, where Shelley fully expected to inherit the family estate in Sussex and to take up a seat in Parliament. In the event, his father Sir Timothy survived an unconscionable time, but Shelley would surely have become involved with the Great Reform Bill of 1832. After serving modestly on the London Greek Committee, he might have starred in the radical *Westminster Review*, and sharpened up the young liberal philosopher J.S. Mill. He might have hobnobbed with Coleridge at Highgate ('a little more laudanum, Bysshe?'), compared notes on their translations of *Faust*, grown heated about 'atheism' and cool again about that damn Laureate Southey.

Later still might have come the famous 'Odes to Electromagnetism', the seditious verse play about Chartism, the suppressed 'Essay on the Variety of Sexual Intercourse'. Finally perhaps, we can imagine him being scandalously elected as the first Professor of Poetry and Politics at the newly founded, and strictly secular, University of London.

Mary too, despite her love of Italy, would surely have been drawn back to England, with or without (a different counter-factual story) Shelley. In the 1820s she was anyway to become famous in her own right through no less than five different stage productions of *Frankenstein* in London. Her long-awaited third novel, *The Last Man* (1826), might well – in other circumstances – have been her second masterpiece. Based on another brilliant and prophetic science-fiction idea, she imagined the entire human race relentlessly destroyed by plague. But lacking the intellectual stimulation of the lost Shelley-Byron circle, the novel became diffuse, mawkish and nostalgic: it was dominated by wish-fulfilment portraits rather than the intense psycho-drama of *Frankenstein*. In their own way these were also Mary's version of counter-factual lives. Byron is resurrected as the glamorous Lord Raymond, the commander of a liberated Constantinople; Shelley as the withdrawn but altruistic Adrian, the protector of a republican England (a real legislative office); and Mary herself changes sex to become the intrepid Verney, the eponymous Last Man, a born survivor and solitary wanderer, who returns undaunted to a deserted Rome. In the penultimate chapter, the most powerful of the entire novel, Mary restages the wreck of the *Don Juan* in agonisingly re-imagined detail.

Of course it is also true that if Shelley had lived, Mary would not have had to spend nearly twenty years editing his papers and writing fashionable journalism. Instead of sending her son to Harrow, and turning her husband into a posthumous angel, she could have really given her mind to developing her fiction. Her novels – *The Fortunes of Perkin Warbeck* (1830), *Lodore* (1835) and *Falkner* (1837) – might have rivalled Bulwer-Lytton, or at least Harrison Ainsworth.

What do these counter-factual speculations say about the nature of biography itself? First, that we have an unconscious hunger for explanatory myths. We like our 'Lives' to conform to archetypes, or fables, or even fairy tales. Built out of understandable piety, admiration and regret (but also out of guilt, embarrassment or remorse), myths are easily formed but difficult to change. They may even require the shock, the impiety of laughter.

Second, we need to consider alternative versions. For instance, a Shelley who was reckless rather than ineffectual, generous rather than angelic, self-centred rather than suicidal, intellectually isolated rather than politically despairing. A Shelley firework, say, more than a Shelley jelly. Above all, we need to consider a Shelley who was a writer of genius still at the outset of his career, rather than at its end. And,

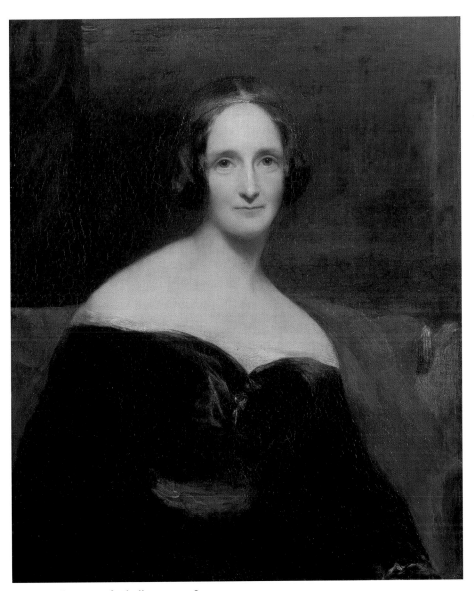

Mary Wollstonecraft Shelley, 1797–1851
Richard Rothwell, exhibited 1840
Oil on canvas, 737 x 610mm (29 x 24")
National Portrait Gallery, London (NPG 1235)

with double irony, the same possibility for his wife Mary.

Third, we need to face the crucial difference between chance and destiny, in biographical narrative. The underlying trajectory of a life is always hard to gauge. Mary herself came to reflect on this, puzzling over why she and Shelley ended up at Casa Magni at all. 'But for our fears on account of our child, I believe we should have wandered over the world, both being passionately fond of travelling. But human life, besides its great unalterable necessities, is ruled by a thousand Lilliputian ties that shackle at the time, although it is difficult to account afterwards for their influence over our destiny.'[5]

Finally, we always need to re-examine the role of time in biography. What is 'a lifetime'? What is 'the time of death'? (Shelley's watch, now preserved in the Bodleian Library, Oxford, is stopped at precisely sixteen minutes past five.) Is human time different from historical time? Writing in *Orlando* (1928), her sprightly satire on conventional biography, Virginia Woolf observed: 'It's a difficult business, this time-keeping. The true length of a person's life, whatever the DNB may say, is always a matter of dispute.' The 29-year-old Shelley remarked to Hunt at Livorno, just before he died, that he felt he had lived to be older than his grandfather − 'I am 90 years old'.

Shelley's theory (based on the philosophy of Hume) was that human time is not experienced uniformly, but is controlled by speed and intensity of impressions and ideas. As he had written ten years earlier in *Queen Mab*: 'The Life of a man of virtue and talent, who should die in his thirtieth year, is − with regard to his own feelings − longer than that of a miserable priest-ridden slave, who dreams out a century of dullness ... Perhaps the perishing firefly enjoys a longer life than the tortoise'. Certainly human time is not divided into equal chapters. Nor is the 'death scene' the true end of any significant human story. We need to be aware that many lives change their shape as we look back on them. The dead may always have more life, more time, to give us. Shelley may always be 'unextinguished', undrowned.

Notes
1 Matthew Arnold, 'Shelley', *Essays in Criticism* (second series), 1888.
2 Mary Shelley, letter to Jane Williams, 18 September 1822.
3 Shelley, letter to John Gisborne, 18 June 1822.
4 Mary Shelley, letter to Maria Gisborne, 30 November 1821.
5 Mary Shelley, 'Note to the Poems of 1820', in Shelley, *Poetical Works*, 1839.

SHELLEY: A CHRONOLOGY

1792 Birth of Percy Bysshe Shelley.

1797 Birth of Mary Shelley.

1811 Shelley expelled from Oxford.

1813 Shelley publishes *Queen Mab*.

1814 Shelley and Mary run away to Lake Lucerne, return down river Rhine.

1816 Shelley publishes 'Alastor'; Shelley and Mary on Lake Geneva with Byron.

1818 Mary Shelley publishes *Frankenstein*; the Shelleys move to Italy.

1819 Shelley writes 'The Mask of Anarchy' and 'To the West Wind'.

1820 The Shelleys settle in Pisa; Shelley publishes *Prometheus Unbound* and writes 'A Philosophical View of Reform'.

1822 27 April The Shelleys move to the Casa Magni, San Terenzo.

 16 May The *Don Juan* yacht is delivered.

 June Shelley begins 'The Triumph of Life' (unfinished).

 1 July Shelley sails to Livorno.

 8 July Shelley is drowned on return voyage.

 late July Shelley is cremated on Viareggio beach by Trelawny.

 October First edition of *The Liberal* magazine published.

1823 Mary Shelley returns to England.

1826 Mary Shelley publishes *The Last Man*.

1832 'The Mask of Anarchy' finally published.

1839 Mary Shelley publishes her edition of Shelley's *Poetical Works* with her biographical 'Notes'.

1851 Death of Mary Shelley.

1854 Horatio Weekes *pietà* monument to Shelley and Mary installed at Christchurch, Dorset.

1878 Trelawny publishes *Records of Shelley, Byron, and the Author*.

1894 E. Onslow Ford monument to Shelley installed at University College, Oxford.

1920 'A Philosophical View of Reform' finally published.

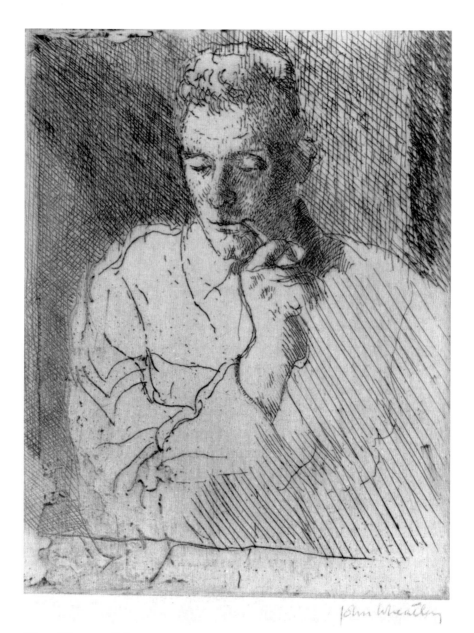

Edward Thomas, 1878–1917
John Laviers Wheatley, 1916
Etching, 126 x 99mm (10⅛ x 7½")
National Portrait Gallery, London (NPG D6937)

Two Roads:
The Life of Edward Thomas

Andrew Motion

Edward Thomas chose to be a writer because it offered him certain kinds of freedom, but spent the first part of his life complaining that he was 'destined to reflect many characters and to be none'. Between 1897, when he published his first prose book at the age of nineteen, and the outbreak of the First World War sixteen years later, he produced thirty volumes of topography, biography and belles-lettres, compiled more than a dozen editions and anthologies, and produced over a million and a half words of review. Although this work made him conspicuous in the Edwardian literary scene, he was haunted by a sense of failure. He was incapable of finding the form in which he could do himself justice; every new venture left him feeling blocked, shackled, disappointed.

The difficulties were echoed in Thomas's private life. He married his wife Helen Noble in 1899 when he was twenty-one, had three children in short order, and spent a great deal of his home-time veering between dependency and resentment. He also spent long periods alone – sometimes in London scouting for literary work, more often tramping the countryside to collect material for his books and to end the 'sort of conspiracy going on [in my head] which leaves me only a joint tenancy and a perpetual scare of the other tenant and wonder what he will do'.

At his best the young Thomas was a scrupulous self-doubter; at his worst he was morbid and excessively self-mortifying. As a result, the story of his first thirty-five-odd years seems at once dizzyingly busy (all that work) and suffocatingly uneventful (all those choked ambitions). It is much more nearly a story of failure than success. One or two of his books are entirely fresh and heartfelt (*The South Country*, for example, and *In Pursuit of Spring*); several contain passages of fine writing; the majority are blighted by haste or padding. The same is true of his marriage. Parts were settled and contented, others frustrated and angry. On at least one occasion, when he was overwhelmed by professional and personal worries at the same time, he contemplated suicide. 'It is,' he wrote in his diary on 9 October 1907, 'dislike of the effort to kill myself and fear that I would not carry it through if I half did it that keeps me alive. Only that.'

It took a stronger personality than his own, and an irresistible event, to set Thomas on a new road. In October 1913 he met Robert Frost, who had been living in England for the previous year. Frost bombarded Thomas with sympathetic verse-

theories about 'the sound of sense', boosted his self-confidence, and soon succeeded where others had failed in persuading him to leave 'his old nest of prose' and start writing poems instead. 'When it came to beginning I slipped into it naturally,' Thomas said, remembering Keats's opinion that poetry should come as naturally as leaves to a tree. In the next two years he wrote almost 140 lyrics, often plundering his previous prose books and re-casting their best passages.

Frost was a driving force for Thomas, but his influence was confirmed by the war. As its shadows closed round Thomas through the spring of 1914 they concentrated his mind by focusing his feelings for England, which had always been his subject as well as his home, and by forcing him to take decisions. Frost was about to return to America and wanted Thomas to go with him. Thomas was tempted, but conscious that he had other and more fundamental commitments. At the age of thirty-six there was no strong pressure on him to enlist, but in August 1915 he finally made up his mind. He abandoned the idea of visiting America, and joined the Artists' Rifles. When his friend Eleanor Farjeon asked him why, he scooped up a handful of earth and said 'For this'. It was a confident gesture, but ambiguous – patriotic and also deathly. At this time the average life-expectancy for a British officer in the trenches was one month.

Thomas spent a year and a half in training camps then sailed to France at the beginning of 1917. A few weeks after he arrived in the trenches *An Annual of New Poetry* was published, containing eighteen of his poems under the pseudonym Edward Eastaway. His new life as a soldier and his new life as a poet were still inseparable. Inseparable but precarious, as he reported in his diary on Easter Day, on the eve of the Battle of Arras:

A bright warm Easter day but Achincourt shelled at 12.39 and then at 2.15 so that we all retired to [the] cellar [of the billet]. I had to go over to battery at 3 for a practice barrage, skirting the danger zone, but we were twice interrupted. A 5.9 fell 2 yards from me as I stood by the f/c post. One burst down the back of the office and a piece of dust scratched my neck.

Dud shells were not uncommon in the trenches, but this failure seemed to Thomas to be a sign. When his Commanding Officer, Major Lushington, teased him about his narrow escape, then asked, 'Whose turn is it for O[bservation] P[ost] tomorrow?' Thomas said it was his. Another officer chipped in that 'a fellow who was as lucky as he was would be safe wherever he went.'

The following morning, Easter Monday 9 April, Thomas arrived at the Beaurains OP before first light. The artillery barrage began as the sun rose, with Thomas reporting back to the gunners on a field telephone, and sheltering in a

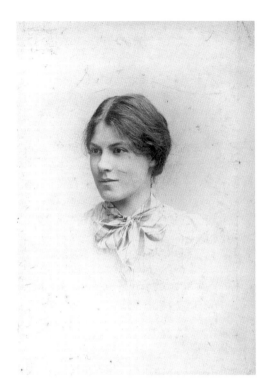

Helen Thomas, 1877–1967
Walter H. Barrett
Cabinet print, 147 x 101mm (5¾ x 4")
Myfanwy Thomas

crater from incoming fire. At 7.36 a shell landed nearby, just as he was standing to fill his clay pipe. The blast poured over him, squeezing his heart and wrinkling the diary – and a letter from Helen – that he had tucked into his pocket before setting out. As he staggered backwards, a piece of shrapnel skimmed towards him, missing his chest but lacerating his left arm between the wrist and elbow. He collapsed into the shell-hole unconscious. Stretcher-bearers recovered him that evening. He later wrote of the 'strange, almost mystical swaying between earth and heaven' he had endured in the shell-hole, and of the 'bafflement' he felt the following day, when he woke after surgery in the field hospital to find that his left arm had been amputated below the elbow.

Helen's relief that Thomas's life had been spared overwhelmed all her other feelings. For the remainder of the war – which held most futures in suspension – they were happier than at any time in their marriage. As they took short walks together, gardened together, read to the children together, Thomas had no choice but to accept Helen's help, and she felt that by taking complete charge of her husband's life she was at last 'being of some use'.

There was another reason for the change in Thomas. Before leaving for France

he had arranged for the publication of his first collection of poems to appear under his own name. When the book came out in mid-1917, dedicated to Frost, its reception helped to convince Thomas he had indeed 'risen from the ashes' of himself. He told Frost, 'my critics, I admit, have given me more satisfaction than I expected and I dare say deserve. They at least will be content if I persevere.' Frost's own reaction to the book was predictably enthusiastic ('it is good with a whole lifetime of goodness distilled'), yet flecked with a trace of possessiveness. Reminding Thomas of his own more dramatic achievements in the monologues of *North of Boston*, he ended by urging Thomas to 'flex that strong right hand of yours to unroll the larger canvasses you are equipped to fill'. Thomas took the advice without a murmur, apparently unaware of Frost's controlling instincts.

While Thomas was still training to be a soldier he had often felt unlike himself. 'Is peace going to awaken me as it will so many from a drugged sleep?' he had written to Frost from Hare Hall Camp, in Essex, late in 1915; 'Am I indulging in the pleasure of someone else?' But when the Armistice was signed in 1918 he found it was impossible to turn back into the person he had once been. The pain and inconvenience of his arm meant that long 'tramps' were now beyond him, which in turn meant that a major part of his writing, and of his income, was also taken away. Besides, the market for books like *The South Country* had shrunk. As England struggled to put the war behind it, and moved towards the Jazz Age, Thomas's kind of prose seemed suddenly quaint and out of date. In the summer of 1919 he wrote to his friend Gordon Bottomley, admitting that the 'strange holiday' he had enjoyed since returning from France could not last much longer. 'If I met the old ET on the road today' he said, 'I could not fall in with him and talk in the familiar way. If I am to continue, it must be thanks to some desperate remedy. Which remedy I have yet to discover, though the siren songs from north of Boston are ringing in my ears.'

When Thomas considered Frost's repeated invitations to visit New England he was determined to look on America not merely as a refuge but a land of opportunity. He was used to new beginnings, but what he called 'my American experiment' was a more drastic step than any he had taken before the war. All the same, he persuaded himself that his decision was as 'natural' as his 'slip' into poetry: he sailed from Liverpool to Boston in February 1920, expecting not just a warm welcome but a continuing shared journey of discovery. He was right to feel confident – Frost greeted him as 'a lost brother', and for the first few weeks was always on hand to give help and advice. But as the thrill of novelty wore off, tensions began to emerge. It was almost exactly five years since Thomas and Frost had last met, and although they had corresponded busily, neither was quite prepared for the changes they found in each other. As far as Frost was concerned, Thomas was still the tentative almost-poet he had first encountered in 1913; Thomas, for his part, still

thought of Frost as a foreigner who needed his social and literary help. In fact Thomas was more decided than before, and Frost was simply a great deal more bullish. *A Boy's Will* and *North of Boston* had been successfully published in America in 1915, and when *Mountain Interval* followed in 1916 Frost was generally recognised to be one of the leading poets of his generation − much in demand as a teacher and well-paid reader of his poems. In his first letter home to Eleanor Farjeon, written a month after his arrival in America, Thomas said: 'Robert surprises me by seeming a little larger in himself than I remembered, and a little more determined to make my life a part of his own. Am I to be the lady chapel and he the cathedral?'

Thomas had arranged to travel ahead of Helen and the children, who arrived in Boston four months after him in June 1920. Frost was in the process of leaving a farm in Franconia, New Hampshire (because the 'winter killed apple trees,' he said to his English friend Jack Haines), and was settling with his family 'a hundred miles further south and out of the higher peaks' in South Shaftesbury, Vermont. He suggested that Thomas make his home in the farm at Franconia, and arranged for him to teach literature for a few hours a week at the local High School. In addition Thomas was expected 'to keep an English weather eye' on Franconia, for which he would be excused paying rent.

Neither Frost nor Thomas wanted to admit that things were uneasy between them. Frost frequently stayed at Franconia, walking with his friend through the surrounding orchards, and talking late into the evenings on the veranda. There were, however, two clouds on the horizon that neither man could ignore. One was the reserve that Thomas felt in Frost's response to his recent poems. As Thomas absorbed the New England landscape, he continued to adapt the strict naturalism of his early pieces. But while Frost chose to embed his own darker thoughts in expansive monologues, or in shorter poems which seldom strayed from smooth-flowing iambic pentameters, Thomas wrote nervously, even sketchily, winnowing from his lines the last traces of nineteenth-century poeticism, and producing a series of tense, terse lyrics which often convey a sense of fragmentation.

In this respect, and also because they include shockingly matter-of-fact memories of the war, these poems break Thomas's last remaining ties with the Georgians, and affiliate themselves to the experiments launched in the late 1910s by Ezra Pound and T.S. Eliot. When Thomas had reviewed Pound's *Personae* in London he had first been enthusiastic, then recanted. Now he seemed to be changing his mind again − not by launching after Pound into obscurity, but by harnessing the distraught spirit of modernism to the traditions of time-honoured pastoral. Frost would later say, 'I like to read Eliot because it is fun seeing the way he does things, but I am always glad it is his way and not mine'; when Thomas read *The Waste Land* soon after it appeared in 1922, he wrote to Eleanor Farjeon:

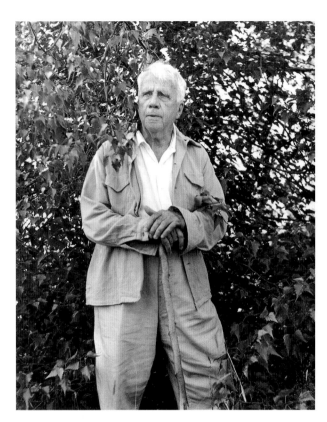

Robert Frost, 1874–1963
Rollie McKenna, 1952
Vintage bromide print,
318 x 250mm (12½ x 9⅞")
Estate of Rollie McKenna

I am left stumbling, of course, in my stretch after some of the allusions and so on. But the whole of it, the *feel* of it, is something I recognise and think I have always known. This is no small achievement for something so obviously new, and I would rather greet it with open arms than go to the wall as a back-slider or any of the old brigade.

Although Frost doubted the direction his friend's work was taking, he now encouraged Thomas to publish a second collection of poems (it was three years since *Poems* had appeared). Thomas gave the idea serious thought, even going so far as to draw up a contents list, but in the end decided to wait. His reasons, given in a letter to Frost in June 1921, shed a bright light on the changes that he felt he was undergoing as a writer:

You are quite right that my readers, such as they are, may forget me if I do not publish. But when I review what I have done over the last years, I hesitate. I

suspect a publisher would want to advertise me as 'a war poet' and I cannot feel happy with that pinned on my chest along with my medal and my empty sleeve. For one I was in France for so little time, I cannot feel I deserve the accolade. For another, my reflections on the war – though numerous enough – have never or rarely been about war and war alone. I am not Sassoon, and am glad to have been spared the reasons why I might be. For another, I have a sensation of moving between fixed points, and am disinclined, as a result, to report on my whereabouts since I do not entirely see them myself.

The second 'American problem', as Thomas called it, was more acute and more personal. Even though his marriage to Helen had often been turbulent he had always remained faithful to her – and made a point of owning up to his few innocent 'infatuations'. When Frost's wife Elinor introduced Thomas to the daughter of her former school friend Betsy Bellingham, shortly after he had arrived in Franconia, he succumbed again.

Ruth Bellingham was eighteen – an eager, clever school graduate who lived with her parents near Thomas's farm. It is unlikely that she had any intention of doing more than capturing his attention – to start with, at least. But in the comparative isolation of Franconia, and with his self-esteem weakened by the lurking difficulties of his friendship with Frost, Thomas soon began to lose control of his feelings for Ruth. By May she was visiting him almost every day.

Most of the written evidence for their relationship comes from the reminiscences of Frost, and a single confessional letter Thomas wrote to Jack Haines in England. In this he admits to seeing Ruth regularly, describes her as 'my open-hearted New England admirer,' and says, 'I would say I am in love with her, always supposing I have a heart capable of loving'. Frost later corroborated this. 'Edward,' he told a mutual friend, 'became enamoured of a young lady at around this time, which all things considered was not to be wondered at. What was remarkable was how much it consumed him, and how the damage done by the thing became greater than the thing itself.' Frost meant that Thomas had not only damaged his marriage but their friendship. Even though he continued to make regular visits to Franconia, and had ample opportunity to walk and talk with Thomas, he resented not having the whole of his attention. This, combined with his hesitations about the divergence in their work, threw a shadow over their friendship.

The situation was even more difficult for Helen. When she arrived at Franconia with the children in late June, and was introduced by Thomas to Ruth, she saw at once that her dreams of a happy reunion had been dashed. Within a matter of days, she confronted her husband, who responded with his customarily awkward honesty but remained stubborn. He continued to see Ruth several times a week as the

summer turned into autumn, and although Helen tried to accept her diminished role in things, she and Thomas knew a crisis was inevitable. It came in September, when she announced that 'living in this odd, lopsided triangle' was impossible, and told Ruth's parents that she wanted their daughter to stop seeing her husband. The Bellinghams, who had supposed Ruth's visits to Thomas were innocent and merely friendly, were shocked, and immediately dispatched Ruth to stay with her aunt in Boston for an indefinite period.

In the weeks after Ruth's departure, when Helen expected that he would 'come back' to her, Thomas withdrew even further into himself. He stopped writing poems. He took little interest in the farm. Frost grew impatient with him (calling him 'a booby') and more than impatient with Helen. Helen herself became so wretched that by Christmas she accepted yet another change was necessary. She offered to return with the children to Steep, having lived in America for eight months. Thomas stayed for another year – a year of little achievement and evident unhappiness. His main task before leaving Franconia was to repair his relationship ('mend his walls', as he later put it) with Frost and Helen. Over the next few months he came to feel that Frost was actually a part of the difficulties he now faced. There was no obvious anger between the two men, no showdown, but a strengthening sense in Thomas that his friend was partly responsible for the hiatus in his marriage.

By the following summer, Frost and Thomas were often meeting again, and 'getting on famously,' as Thomas said to Helen. 'By which I mean he goes about it famously, and I in my less conspicuous way.' As this suggests, both men were working to keep up appearances, but knew the bloom had faded from their friendship; although they continued to defend each other in public, and professed how close they were and always had been, their unique connection had been broken. They would never again be 'elected friends'.

Helen was more forgiving. In a series of long letters written from Franconia during the summer and autumn of 1921, Thomas reassured her of his love without ever quite apologising for his interlude with Ruth, or asking for forgiveness. Helen told Janet Hooton she was 'not alarmed' by this. 'I have known him too long, and too well, to expect him to creep back to me – it is not his way. If he comes at all it will be as a man who feels that he has made his own decisions, and not because he pities me or the children. For myself, I will be happy. My existence is like a shadow without him.'

Thomas turned back towards Helen with a characteristic slowness. She was as ready for him as her word. When he eventually packed up at Franconia, and sailed to Liverpool in the autumn of 1922, she stood on the quayside to meet him. By this time, after his many twistings and turnings, Thomas was indeed convinced that he had made a free choice. Helen later described how quickly they resumed their old

routines — with Thomas soon producing enough reviews and other kinds of hack literary work to keep his family afloat. If either of them felt an irreparable harm had been done to their marriage, they never said so.

In the spring of 1923 Helen told Eleanor Farjeon that she felt she had Thomas 'back from the war a second time, to heal and help.' But it was Thomas himself who took the most decisive step towards recovery: he at last agreed with his publishers to put out his second collection of poems, *The Apple Orchard*. It appeared the same month as Frost's fourth volume, *New Hampshire*, but now the differences between the two poets were as striking as their similarities. Frost's book contains many of his best and best-loved poems. It celebrates eternal verities and natural rhythms in generally colloquial lines, perfecting the sagacious fireside manner which would soon make Frost the most popular poet of his day.

Thomas's book is much more agitated and highly strung. In the several poems which deal directly with the war ('The Fire Step', 'Larks by Night') he is never as graphic as Siegfried Sassoon or Wilfred Owen, but certainly catches the same sort of pathos — the pathos of mangled pastoral — that appears in Isaac Rosenberg's 'Dead Man's Dump'. Elsewhere in the volume, whether Thomas is writing about his farming experiences in New England or his knotted feelings for Ruth and Helen, he develops the painful candour which first appeared in his so-called 'household poems' of 1916, in which he had told Helen he would give her 'myself ... if I could find / Where it lay hidden and proved kind'. Invariably the poems are built on a smaller scale than Frost's, and they lack the grandeur of his confidence. The compensation is a thrilling sense of particularity — they seem written with no barrier or defence between the poet and his subject. Not surprisingly, many of the book's reviewers commented that it bore distinct resemblances to Eliot's *The Waste Land*, which had appeared the previous year. As the *Chronicle* said: 'Mr Thomas's poems may not have the evident learning and cosmopolitan range of Mr Eliot's modern epic, but they arise from and inhabit the same darkness.'

Thomas's book did not earn him much money, but it did make his reputation as one of the foremost English poets of the 1920s — and brought him other kinds of reward as well. One he especially valued was a letter from Thomas Hardy inviting him to call on him at Max Gate. Thomas had always admired and often reviewed Hardy's work, and judging by his report to Frost of their first encounter, they hit it off at once. 'TH,' Thomas told Frost, 'is like his own darkling thrush — a little, eager, piercing man singing beautifully among (or I should say against) the shadows. He gave me tea out of a brownish cup and we talked of you among other matters. He has asked me to visit him again, and I shall. His wife hovered as I was leaving; she has the air of wanting to fuss over him, but hardly seems to know him. He showed more affection to his dog; a curious business.'

Thomas met Hardy at least six more times during the next few years, and came to see him as a 'venerable, if not a candid friend'. They were never intimate (their correspondence was sparse, and always concerned with practical details of their meetings, rather than more personal things), but they evidently felt validated and encouraged by one another. Hardy admired the naturalism in Thomas – even borrowing from Thomas's poem 'Out in the Dark' for his own 'The Fallow Deer at the Lonely House' – and Thomas felt a deep kinship with the realism and plangency of Hardy's vision.

Hardy respected Thomas's melancholy; it echoed his own bleak view of the universe. But he had no way of knowing how large a step Thomas had taken into unhappiness since his return from Franconia. Thomas's other friends were able to make a better judgement. When he toiled up to London looking for review work, and arranged meetings with poet-colleagues such as Harold Monro, Lascelles Abercrombie and Wilfred Gibson, or with fellow naturalists like G.A.B. Dewer and W.H. Hudson, he struck them as 'entirely drained' (in Hudson's phrase). There was none of the occasional pre-war wittiness or the settled equilibrium he had found before leaving for America. 'Truly I am concerned for him,' Monro wrote to Walter de la Mare; 'He comes among us like a ghost, as though this earth is no longer his natural habitation. This would be grave in any case. With ET, who lives on the earth or not at all, it is worse than grave.'

We can see what Monro meant in photographs taken at the time. When Thomas had left for France in 1917 he already looked much older than his thirty-nine years – his face gaunt and his eyes hooded. Now, in his mid-forties, he could have passed for a man of sixty: his clean-shaven face tanned by the sun, but hollow and exhausted-looking; his hair thin; his shoulders stooped; his clothes hanging loosely from his thin frame. No doubt his amputation was partly to blame. No doubt, too, the anxieties of his mainly freelance life had left their mark. But there are also signs of a more fundamental, clinical problem – a physical wasting and degeneration.

Helen was especially concerned. Knowing that before the war Thomas had often visited doctors to complain of stomach ailments, and had repeatedly put himself on particular vegetarian diets, tried to give up smoking, even consulted a friend and advocate of Jung's named Godwin Baynes, she now became convinced that her husband was suffering (as she said to Janet Hooton) 'more in body than in mind, or as much in both'. When she eventually persuaded Thomas to visit a specialist in London in the spring of 1926, she was dismayed but not surprised to hear that he had been diagnosed with cancer of the lower intestine. He was immediately admitted to hospital for an examination, and returned to Steep in the early summer.

By early autumn it was clear to everyone that Thomas was a dying man. Helen feared that his death-sentence would plunge him into solitary misery, but she soon

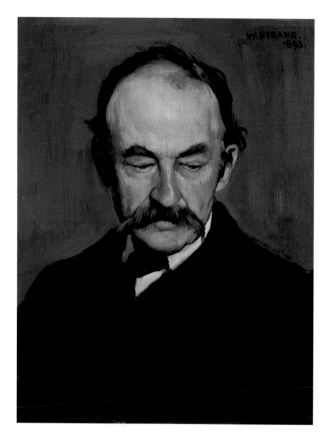

Thomas Hardy, 1840–1928
William Strang, 1893
Oil on panel,
432 x 381mm (17 x 15")
National Portrait Gallery,
London (NPG 2929)

found otherwise. He greeted the news of his illness with the same resolution that he had found as a soldier. Even though he no longer had the energy to walk more than two or three miles at a stretch, and handed over most of the garden chores to Helen, his appetite for writing was actually refreshed by his predicament. Following Frost's example, he ordered the local carpenter to build what he called his 'poet's tray' (a portable sloping desk-top) and spent his mornings 'putting my life in order, or rather into a disorder that may be interesting to others.'

This 'disorder' consisted largely of poems. Before the war, when he was still riding the first wave of his freedom in the form, he had sometimes produced a poem a day. Now the rate was slower but still exceptional. During the next twenty-four months he finished nearly 150 lyrics – none longer than a page, but all shaped by the steady concentration on natural things, and on the imminent loss of those things, which had become his stock-in-trade. But where the mood of his work had once been gently mournful, now it was unflinchingly bleak. The seasons, the

weather, the songs of birds, all prove that he still felt he was 'an old inhabitant of earth', but their signals were always interrupted or actually destroyed by intimations of 'nothingness'. His immediately post-war work had brought him close to the spirit of Eliot; these last poems anticipate the severities of Samuel Beckett.

As a young man Thomas had often complained that his need to earn money (let alone his lack of self-confidence) had kept him from the work he most wanted to do. During his last two years he was at least spared this kind of anxiety. In the same way that he had campaigned in the early 1910s for W.H. Davies to be awarded a Civil List pension, now Davies and others including Hardy petitioned for him – with the result that for the first time in his life he felt (as he said with appropriately heavy irony) 'a free man although I am everywhere in chains'. Rather than spread himself across a number of different plans, he chose to concentrate on one in particular: the completion of the childhood autobiography he had begun many years earlier.

This memoir, which was not published until 1929, has been widely recognised as a classic – a book crammed with insights into the evolution of his writer's mind, and also a moving evocation of the England first threatened and then devastated by the war. It also contains a number of shrewd, sharply etched portraits of famous contemporaries (Frost, Hardy, W.H. Hudson, de la Mare et al.), one of which has a special value, since its subject was not well known at the time Thomas met him. This is the reminiscence of Wilfred Owen.

Owen was in the same regiment as Thomas – the Artists' Rifles – and in November 1916 had been stationed at Hare Hall Camp in Essex, where Thomas was teaching map-reading, field-sketching and the use of a compass and protractor. They only overlapped for a week, and neither had yet published the poems that would make their names. (Owen's poems were first collected, with an Introduction by Sassoon, in 1920.) But Thomas was already known by name to Owen as the author of a short book on Keats, which had appeared earlier the same year.

On 16 November, the day after he arrived at Hare Hall, Owen introduced himself to Thomas. As Thomas remembered in his autobiography,

> He came to me in the mess one evening as an acolyte, as though in writing about Keats I had gained some contact with the immortal spirit. A compact, berry-brown figure still somewhere between boyhood and manhood, very punctilious in his turn-out, with his belt, boots etc waxed to a high polish and his moustache very trim and perfect. I would like to say I felt immediately aware of his genius, but this would not be true. We spoke of Keats, of course, and also of other writers, but nothing he said about them was distinguished by a particular insight. It was his *enthusiasm* which made him stand out. He talked of Keats as though he was an old acquaintance, with whom he had shared confidences. I shall not

easily forget the sunset waning behind him as we sat in our hut, gilding his hair and the side of his face, with the chat and racket of the others continuing around us. He told me he was writing verses, and I confided that I was about the same business myself, and we agreed we should show one another some specimens. But amidst the excursions and alarms of those days, our exchange never took place. I saw him only once more and by chance, when we coincided at the crossing-point of two paths in the barracks. I was on my way to class, and he was off to some other business of his own – hurrying, cramming his cap upon his head. We saluted one another in a scrambling fashion, and smiled, but that was all. When I first read his poems after their publication, I cursed myself for not shaking his hand. Truly, I believe that he had held conversations with John Keats, and had discovered something of his true essence.

Thomas finished his autobiography in the late spring of 1928. His health, as though it had depended on the work, immediately deteriorated. Because he was no longer strong enough to visit London, friends came to him – usually finding him in a wicker chair on the back lawn of the cottage, facing the massive beech hanger which rises behind Steep towards the villages of Froxfield and Uffington (which he had mentioned in his early poems). Helen, who would later write an extended memoir of her life with Thomas, remembered that 'he would watch the trees in a wise silence, as though uncertain whether he expected them to come close and consume him, or himself to rise up and enter their shadows. It is strange to say, but Edwy was more content during those last days than at any previous time. He often told me sorrowfully that he was dying before his time [he was fifty], but also that he felt he had filled his time, not always with happiness, but with the search for happiness at least.'

In September 1928, after staying briefly in France, Frost and Elinor came to England. It was their first visit since 1915, and Frost was anxious to see old friends like Gibson, Abercrombie, F.S. Flint, Edward Garnett, and de la Mare, and also to call on the Poet Laureate Robert Bridges, whom he had last seen in Michigan three years previously. The climax of Frost's tour was lunch at Steep – but it was not a success. Thomas was too ill to sit with his friend for more than an hour, and Frost could scarcely conceal his annoyance that Helen stayed with them throughout. 'O he was polite, all right,' Helen later wrote to Janet Hooton, 'but what is it to be polite at a time such as this? Edward never made a secret of how much he owed to Robert.'

Helen knew, but could not admit, that there were too many ghosts in the cottage that day: the ghosts of Frost and Thomas as young men finding themselves and each other; the ghosts of the war that Thomas had fought and Frost had observed; the ghost of Ruth Bellingham; the ghosts of roads taken and not taken, which had led

the two men in diverging directions. Thomas, however, was beyond making this the reason for anything so obvious as a falling-out; if he felt any unhappiness about this final meeting with his friend, it was absorbed into the larger miseries of his illness.

A week after Frost left England, Thomas took to his bed for the last time. He died in the early hours of 31 October – Keats's birthday – with Helen at his bedside; he was buried in the churchyard at Steep the following Saturday. It was a small gathering ('I wanted to keep him to myself a little longer,' Helen told Janet Hooton), but fraught with a sense of larger significance. The shade of Thomas Hardy, who had died the previous January, was represented by a wreath from his widow, Florence. Frost also sent a wreath; the card was inscribed with nothing more than the two words of his name.

Three months later Helen organised a Service of Thanksgiving in the same church: it was filled to overflowing with friends from the village, London friends, and the whole large network of Thomas's literary friends (including the sickly Gordon Bottomley). Walter de la Mare, who had known Thomas since the mid-1900s, gave the address. Thomas, he said, had 'straddled two worlds and made a bridge between them.' He meant that by surviving the war, and continuing to write poems which were predominantly pastoral, Thomas had conserved what we now know as 'the English line' – the tradition and style which the modernists and the war had threatened to shatter. There is a large element of truth in this, but it makes Thomas sound as though he never developed far from his Georgian roots, and that his poems were essentially of a piece with the work that de la Mare and his contemporaries continued to produce into the middle of the twentieth century. In fact, when Thomas's *Collected Poems* (running to just over 300 pages) was published in 1930, it was his departures rather than his preservations which caught the attention of reviewers, and which have proved the basis of his present-day reputation. In 1914 he had written to Frost 'I want to begin over again ... and wring all the necks of my rhetoric – the geese'. By the time he came back from America in 1923 he had no more necks to wring: his language was as plain as familiar speech, but compressed and nervous to a degree which marks a distinct break with his Georgian origins. He had, in fact, become an English modernist, whose late poems, despite their surface-simplicity and lack of private jokery, have more in common with W.H. Auden (whose adult career began in 1927) than with his eulogist de la Mare. If Thomas had been killed rather than mutilated on Easter Monday 1917 he would have left behind 140-odd poems – enough to prove that he was the best of the Georgians, and to influence successive generations of English poets. But this influence would have polarised a debate between the 'English line' and the modernists – to make the former seem inflexibly cautious traditionalists, and the latter like the standard-bearers for everything radical, forward-looking and

progressive. (It is, for instance, easy to imagine a poet like Philip Larkin feeling that the modernists were antagonistic to his own poetic beliefs.)

As it is, Thomas's work during the post-war years makes such a stand-off unnecessary. Past and future meet in his work, just as peace and war, England and America, health and illness, love and solitude meet in his life. Thomas once called his younger self 'a superfluous man', borrowing Chekov's phrase; in his autobiography (and thinking not only of his amputated arm) he referred to his middle-aged self as 'a patched-up man'. The difference between these two descriptions accurately suggests that by the end of his life he had found ways of reconciling the tensions which formed his character. 'My two roads,' he went on, with an affectionate nod to Frost, 'have become one road – the chalky dust-path of my growing-up, and the hard metalled track of my later time. If they had stayed separate, would they have led me to different destinations? I cannot tell. The best a man can know is that he is easy in the place where he finds himself. I am easy where I am, even knowing that I cannot remain.'

EDWARD THOMAS: A CHRONOLOGY

1878 Philip Edward Thomas born 3 March in Lambeth, London.

1883–94 Attends several different schools in London, the last of which is St Paul's, Hammersmith.

1897 Publishes *The Woodland Life*, the first of many prose books; goes up to Oxford.

1899 Marries Helen Noble.

1901 Rents Rose Acre Cottage near Bearsted in Kent, then three other houses in the next four years, during which he and his wife have a son and daughter; continues to write prose books and journalism.

1906 Moves to Hampshire, where he lives in a number of different houses over the next seven years.

1909 Reviews Ezra Pound.

1910–12 Second daughter born; writes twelve books; begins unfinished autobiography; has nervous breakdown; meets Eleanor Farjeon.

1913 Moves to final home in Hampshire; meets Robert Frost in London.

1914 Holidays with his own family and Frost's wife and children on the Gloucestershire/ Herefordshire border; writes first poem 4 December.

1915 Enlists in July in Artists' Rifles and is sent to Hare Hall Camp in Essex as a map-reading instructor; Wilfred Owen is also stationed at Hare Hall, but there is no evidence of their meeting; Frost returns to America.

1916 Posted to London as officer-cadet in August; publishes *Six Poems* under the pseudonym Edward Eastaway in November.

1917 Goes to France; *An Annual of New Poetry* (containing eighteen poems by Edward Eastaway) published in March; sees a favourable review of the anthology in *Times Literary Supplement* in April; killed by the blast of a shell on 9 April, at the beginning of the Battle of Arras; *Poems* by Edward Thomas published posthumously.

1918 *Last Poems* published.

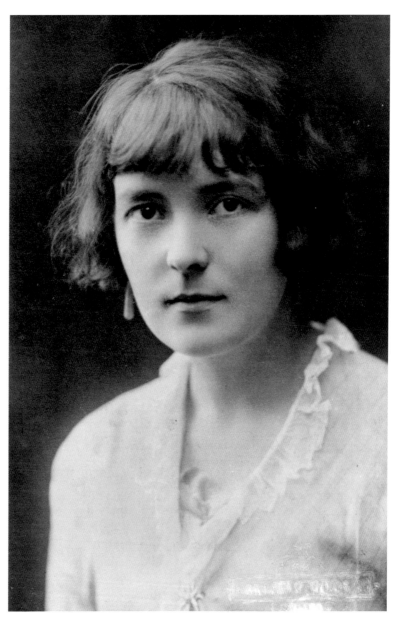

Katherine Mansfield, 1888–1923
Copy by Emery Walker of an original by Adelphi Studios, 1913
Modern print from an original half-plate copy negative
National Portrait Gallery, London (NPG x88511)

Katherine Mansfield: The Writer of the Submerged World

Patricia Duncker

Katherine Mansfield was famous for writing stories which had no introduction or conclusion, but plunged straight in, with a voice, an event, a situation, and then withdrew, as inconclusive as an ebbing wave. She experimented with the short story form and with the representation of consciousness. She was a crucial force in the development of other modernist writers, D.H. Lawrence and Virginia Woolf among them. She appeared as a character in her own stories and in other people's novels; she was the inspiration for the figure of Gudrun in Lawrence's *Women in Love* (1921). Mansfield took lovers of both sexes, wore spectacular clothes, arranged her rooms in eccentric, ostentatious ways. She wanted to be noticed and talked about. She didn't always tell the truth. She cultivated mysteriousness. What she desired most was fame, power and recognition.

Kathleen Mansfield Beauchamp was born in New Zealand in October 1888. She spent most of her writing life in Europe – in England, France and Germany; like many anglophone expatriate writers, myself included, who are not immediately visible as foreigners because English is their native tongue, she was intensely aware that her memories were marginal to the culture of Europe. This awareness of a writing identity that is partially dislocated from the literary tradition to which it is nevertheless firmly attached, is present in all her stories. Her settings are often nameless foreign places: cafés, trains, hotels. Her characters have no past, no future. They are as compelling as creatures from fairy tales, where identity is determined by role. Mansfield was a rich man's daughter, but in England she had no clear social identity. Her ambivalent attitude to Bloomsbury has its source in her sense of herself as an outsider, socially ambiguous and in danger of being excluded. She shared this fear, that she was constantly on enemy territory, with D.H. Lawrence, whose class animosities were bitter and voluble.

Literary friendships between writers who are contemporaries and therefore always in some sense rivals as well as friends, are apt to founder in spoken or unspoken quarrels, unsatisfied desires and ambiguous sexual entanglements. You are each other's readers, each other's critics. Often you will have read each other's work before you meet. This may be the reason why you are meeting at all. Someone else who knows you both will have gossiped about you. Your expectations will have been unreasonably raised. A refusal to conform to a philosophy, a style or a method

to which the other writer, who desires your approval or assent, is passionately committed, will seem like a deliberate rejection, a heartless slight. The paranoid perception of betrayal of one writer by another is often as deeply felt as it is unreasonable. One writer may imagine herself to be rejected by another just because he or she is treacherous enough to think and write differently. The emotions unleashed are as intense as they are absurd. And always, the writing lies before you both, a third presence, studied and assessed in a way that it can never be by any other reader, any other friend.

Mansfield's brief writing life contained literary friendships with two of the most significant writers of the early twentieth century: D.H. Lawrence and Virginia Woolf. She fell out with both of them. In the case of Lawrence, the rupture was spectacular and destructive. But the stakes had been very high indeed. Lawrence wanted a communion of united spirits, a union of souls. He made every effort to persuade Katherine and her lover John Middleton Murray, later her husband, to live near him and his wife Frieda, first in Buckinghamshire and later in Cornwall. Both attempts at the communal fraternity of blood brothers and sisters ended in division and disaster. In her friendship with Mansfield, Woolf made most of the running and often felt neglected and rebuffed. The two writers met for the first time in 1916. Woolf sought Mansfield out and courted her. She felt the truth in Mansfield's comment: 'We have got the same job, Virginia, and it is really very curious and thrilling that we should both, quite apart from each other, be after so very nearly the same thing.'[1] But this truth was not altogether comforting for a writer who was as bitterly jealous of Mansfield's writing as Woolf was. The wariness with which Mansfield received Virginia's overtures was almost certainly based on her fear of rejection. Woolf was haughty, uncompromising, quick to mock and condemn. When he was writing his own autobiography, Leonard Woolf remembered Mansfield: 'She had a mask-like face, and she more than Murray, seemed to be perpetually on her guard against a world which she assumed to be hostile.'[2] In her stories Mansfield often represented a world that was filled with predatory and uncaring monsters.

Mansfield's themes and concerns were very close to those of Lawrence and Woolf. All three writers directly addressed the sexual politics between women and men that was firmly on the political agenda of the period within which they were living. They were also, all three, sexually drawn to their own sex and wrote openly about homosexual love. Woolf and Mansfield both wrote about passions between women. So did Lawrence.[3] But what they had most forcefully in common was bound up with narrative method. None of them are deeply concerned with story or with plot. They do not expect their readers to derive their deeper meanings from patterns in the fictional structure. The moment of visionary revelation,

Virginia Woolf, 1882–1941
Vanessa Bell, 1912
Oil on board, 400 x 340mm (15³/₄ x 13³/₈")
National Portrait Gallery, London (NPG 5933)

unintelligible, potent, precarious, fleeting, the transforming perception grasped and understood – it is here that all three writers rest their authority. They are visionaries. Their method is Wordsworthian. They are all three Post-Romantics. Mansfield, Lawrence and Woolf are all fearless when describing ecstasy. And here I would not underestimate their courage. The danger, which none of them always escapes, is that you will sound meretricious, egotistical and overblown. At worst your writing will read like explosions from an untreated lunatic. It is very hard to be convincing as a writer when the perception you wish to communicate is beyond dailiness and beyond language.

Mansfield shared many stylistic mannerisms with Lawrence and Woolf, such as the habit of beginning as if the story was already under way:

'And after all the weather was ideal.' ('The Garden Party')
'The week after was one of the busiest of their lives.' ('The Daughters of the Late Colonel')
'Of course he knew – no man better – that he hadn't the ghost of a chance, he hadn't an earthly.' ('Mr and Mrs Dove')

Like Lawrence, Mansfield used direct exhortations to the reader, questions, exclamations, language imitating abstract sounds. But unlike Lawrence she is never visible in her texts. There is a gaiety, a lightness of touch, a refusal to preach. Lawrence was often satirical, but he was too convinced of the urgency and truth of his own message to be light-hearted for long. His hectoring, bullying rhetoric, now so unfashionable, is to my mind the meat of the work. He wants to harangue and persuade, by any means available. Lawrence was a prophet who needed disciples, not critics. The register of Mansfield's writing is dominated by the spirit of the satirist, the unbeliever, the sceptic. It is both her strength and her failing. The laughter metamorphoses too easily into a facile sneer. But when she succeeds, the reader's laughter is arrested by the prickle of unease.

Mansfield was a short story writer. She began novel projects, but never finished them. Yet in her finest stories she achieved what Woolf strove to create throughout her writing life: the lightness of the sketch, preserved in the finished work. The short story, as a literary form, has a mixed history. It has remained the place, beloved by difficult literary writers, in which to experiment, a form that is suggestively close to the narratives of the unconscious and to dreams. It is also a form that has a long history as a magazine filler and still occupies a narrative twilight zone in publications such as *Take A Break*. Mansfield pushed the short story form in daring directions. She took hold of small incidents, gestures, inconsequential objects – a friend bringing violets, the gift of a doll's house, a grey fur muff, a hat that is too

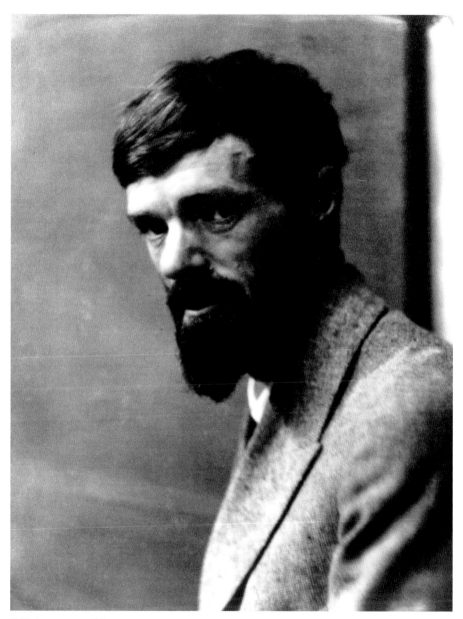

D.H. Lawrence, 1885–1930
Nickolas Muray, 1923
Vintage bromide print, 241 x 194mm (9½ x 7⅝")
National Portrait Gallery, London (NPG P208)

small, a pear tree in blossom – and built them into a complex architecture of competing meanings. The stories do not settle easily or comfortably in the reader's mind. They raise questions that are left hanging. What does the telegram say at the end of 'Something Childish but Very Natural'? What happened to Mouse, abandoned in Paris in 'Je Ne Parle Pas Français'? Or the Little Governess who fell prey to the wiles of the lecherous old man with the twitching knee? Did the Daughters of the Late Colonel ever get away to Eastbourne and carry on with gentlemen? All the stories suggest different, unwritten stories, new stories, stories with other possibilities, other stories with even grimmer endings. Remembering Mansfield, eight years after her death, Woolf commented, 'she came out with a swarm of little stories, and I was jealous no doubt, because they were so praised'.[4] A swarm of little stories. The stories are like wasps or bees. They each had their own sting.

Mansfield's kinship with Lawrence was based not only on their shared sense of marginality in relation to the high literary culture of London's Bloomsbury and Garsington, Oxfordshire, but on their common sense of wonder at the miracle of ordinary things. In one of Mansfield's finest stories, 'The Escape', a husband and wife, fatally at odds, try to catch a train in Southern France. Neither character is given a name, but the bullying wife has the upper hand. The violence of the relationship is buried in the detail.

> The little bag, with its shiny, silvery jaws open, lay on her lap. He could see her powder-puff, her rouge stick, a bundle of letters, a phial of tiny black pills like seeds, a broken cigarette, a mirror, white ivory tablets with lists on them that had been heavily scored through. He thought: 'In Egypt she would be buried with those things ... '[5]

These are the things she values. These trivial objects are her weapons. These are the things that make him long to kill her. The menace that is never far from the surface in Mansfield's writing is here in the 'shiny, silvery jaws' of the handbag, and in the fact that the husband's submerged desire is for his wife's death. But the story doesn't end with division and murder. The husband sees a tree inside a garden gate:

> It was an immense tree with a round, thick silver stem and a great arc of copper leaves that gave back the light and yet were sombre. There was something beyond the tree – a whiteness, a softness, an opaque mass, half-hidden – with delicate pillars. As he looked at the tree he felt his breathing die away and he became part of the silence. It seemed to grow, it seemed to expand in the quivering heat until the great carved leaves hid the sky, and yet it was motionless.

And then from within its depths or from beyond there came the sound of a woman's voice. A woman was singing. The warm untroubled voice floated upon the air, and it was all part of the silence as he was part of it.[6]

The revelation of the woman singing is given no explanation and no precise meaning, but the man's life is transformed. Throughout the narrative the reader hears nothing but the wife's voice, high pitched, nagging, scolding, filled with rancour and selfish irritation. But this is another voice, abstract, unbidden, which offers more than a reprieve from daily marital discord. The woman singing offers a different vision of reality, an opening into another world.

'The Garden Party' occupies Lawrence's territory in that it is a sharp but understated piece about class boundaries. The setting is New Zealand's wealthy colonial society. Laura, highly-strung and over-sensitive, hears that a young man from their local cottages has been killed in an accident. She wants to stop the festivities. Instead she goes down to the squalid cottages in her best clothes and big hat with velvet streamers, carrying a basket of scraps from the garden party, dressed as Lady Bountiful. This story is about running out of emotions to feel and the words to express them. It is also about exchanging the clichés of self-aggrandising pity for real feeling. 'The Garden Party' is therefore about the limits of language. When she is faced with the beauty of the dead man, all Laura can do is apologise for her clothes. She feels that she must say something to the corpse: '"Forgive my hat," she said'.[7] This is a wonderful moment because it is funny, appalling and heart-rending. Laura cannot cross the class barrier before her and has no words with which to greet the dead. She therefore concentrates on surfaces and objects: her clothes, the odious basket. But Mansfield interprets the experience for her in an unexpected way. The garden party is in full swing, but the real event has taken place elsewhere. 'While they were laughing and while the band was playing, this marvel had come to the lane.'[8] The secret beauty of the dead man is the gateway, the opening into another world.

Mansfield was concerned to present the experience of characters on the other side of the class wall. Class division was one of her subjects. She does this best when she dramatises the small, daily symptoms of class conflict – the jeering waiter in 'The Little Governess', who takes great pleasure in being rude to the governess who has been rude to him, and Laura's misplaced, patronising visit to the cottages. A story such as 'Life of Ma Parker', however, which presents a working-class cleaning lady as a downtrodden victim with nowhere in the world to weep, wallows in cheap sentiment. It was this aspect of Mansfield's writing that irked Virginia Woolf. 'Life of Ma Parker' exudes easy, unearned emotion. And Mansfield was often guilty of glib, superficial gestures. This is one of the dangers of the short story form which,

like poetry, demands a sequence of highly charged and significant moments. The prose must be concentrated and demanding. It is a register that is hard to maintain.

Mansfield's most powerful mature stories – 'Prelude', 'At the Bay', 'The Doll's House', 'The Garden Party' – were all set in New Zealand. The release of memory was bound up with the death of her brother Leslie, who managed to blow himself up with a grenade within a week of arriving at the front in 1915. Mansfield's act of commemoration and memorial was to write their shared childhood, just as Woolf was to write a sustained elegy for her dead brother, Thoby Stephen, in *The Waves* (1931). Mansfield's intention was to vindicate the 'undiscovered country'. She wrote: 'I want for one moment to make our undiscovered country leap into the eyes of the Old World.'[9] It was an important assertion, not only of her writing identity, but also of her subject. 'Prelude' began life as a shorter story, 'The Aloe', and was originally planned as a novel; Leonard and Virginia Woolf published it themselves on the Hogarth Press in July 1918. Thus this work joins the roll-call of modernist masterpieces which began life on their dining-room table, and included Gertrude Stein's *Composition as Explanation* (1926) and T.S. Eliot's *The Waste Land* (1922).

'Prelude' is simply a sequence of scenes about a family moving to a new house. 'At the Bay' is about the same family at a summer beach house. The landscape, the vegetation, the birds and the strangeness of the social context make it clear that this is not England. Yet the family, what they say, what they eat – strawberries and cream or bread and dripping – recall the English middle classes: wealthy, leisured, numerous. The central consciousness is Kezia, the child growing up. 'Prelude', like Wordsworth's epic, records the growth of a writer's mind. The moments of visionary horror are there too in Mansfield's 'Prelude': the slaughter of the white duck, which waddles headless before the children, the fear of 'IT', that unnamed lurking terror 'just behind her, waiting at the door, at the head of the stairs ... '.[10] Childhood, and the memories of childhood, with all its shifting perceptions, remains the source of the imagination.

Both 'Prelude' and 'At the Bay' record, above all, the fissures and tensions in human consciousness. Each scene is complete in itself and does not build on the previous scenes. The structure is deliberately endless, fragmented. Only the house, the beach house or the house in the country, and the family, an eternal topos in English writing, hold the narrative together. The dialogue is direct and naturalistic, revealing each of the characters as they negotiate their connections with each other. What is not said, or never can be said, is as present on the page as the words spoken. Mansfield's New Zealand stories are never cosy or sentimental. Her characters, unknowing, anguished, insouciant, selfish, insecure, all seem doomed to follow an unwitting destiny. The wife, Linda, loathes her husband or the new baby one moment and soothes him the next. Each character is identified by role: the

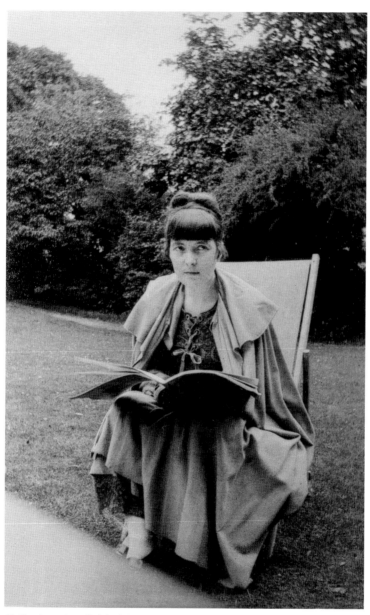

Katherine Mansfield, 1888–1923
Lady Ottoline Morrell, 1916
Vintage bromide print, 131 x 81mm (5⅛ x 3¼")
National Portrait Gallery, London

grandmother, the sexy, bitchy aunt, the Pa-man, Stanley Burnell, an obtuse and selfish patriarch, who is nevertheless treated with knowing sympathy:

> Oh, the relief, the difference it made to have the man out of the house. Their very voices were changed as they called to one another; they sounded warm and loving and as if they shared a secret.[11]

The conspiracy of women was a constant theme in Mansfield's work, but unquestioned solidarity certainly was not.[12] The stories, taken as a whole, represent, as I have said, a sequence of complex, competing meanings.

Any form of conventional credo was impossible for Mansfield, but in a letter to Ottoline Morrell she expressed her conviction that 'nevertheless there is something at the back of it all – which if only I were great enough to understand would make everything, everything, indescribably beautiful'.[13] I am inclined to take this seriously because it is so often expressed in the stories, the marvel of the dead man in 'The Garden Party', the vision of the tree in 'The Escape', the two women in 'Prelude' gazing at the aloe which flowers once in a hundred years. These moments of communion and of ecstasy were the secular equivalents of religious vision. Mansfield, Lawrence and Woolf sensed this dimension in their world: their subject was language, perception and consciousness and the ways in which these elements revealed and concealed each other. Whatever these things might be, they had to be reached by fracturing the conventional forms of fiction. If this meant assaulting the reader with strangeness, or ruffling the surface of the prose, then so be it.

Katherine Mansfield died of a fatal haemorrhage on 9 January 1923. At the end of her life she fell into the hands of quacks and charlatans, as we often do when we are facing death and there is no other hope. She was thirty-four years old. When a writer dies young, her work unfinished, we tend to dwell on what might have been, what she might have written, the directions her work might have taken. But what happens to her contemporaries, to the writers who have lost that distinctive signature that was part of their writing lives? They have lost a rival, a presence in their literary landscape, but above all, they have lost a reader. Virginia Woolf dwelt on this absence when she recorded her reactions to the news of Mansfield's death in a lengthy diary entry (16 January 1923).

> Nelly said in her sensational way at breakfast on Friday 'Mrs Murray's dead! It says so in the paper!' At that one feels – what? A shock of relief? – a rival the less? Then confusion at feeling so little – then, gradually, blankness and disappointment; then a depression which I could not rouse myself from all that day. When I began to write, it seemed to me there was no point in writing.

Katherine wont [*sic*] read it. Katherine's my rival no longer. More generously I felt, But though I can do this better than she could, where is she, who could do what I can't! ... And I was jealous of her writing – the only writing I have ever been jealous of ... I have the feeling that I shall think of her at intervals all through life.[14]

For the writing relationship between the living and the dead continues and persists, and Virginia Woolf knew that it would. The lost voice becomes an echo in the living writer's prose.

Mansfield haunted Woolf's themes and structures. *Mrs Dalloway* (1925) addressed a society divided by rigid class structures: here is a party, and a snobbish, fragile London hostess stricken into consciousness by a working man's death. *To the Lighthouse* (1927) was Woolf's own version of the family in 'At the Bay'. Mr Ramsay's bullying presence inexorably recalls the less dangerous Pa-man, Stanley Burnell, and the women who find themselves exhausted from supporting him. *Between the Acts* (1941), Woolf's last work, written in the darkest moments of the War, more than any other achieved the lightness of a sketch in the finished work. Her last work contains many elements that were characteristic of Katherine Mansfield, the directness and speed of the short story, the couple at odds, and an unexpected satirical energy. The concern with history, however, is entirely characteristic of Virginia Woolf. Mansfield's characters stepped out of nowhere into her stories. To be concerned with history requires a commitment both to a place over time and to time itself. Mansfield lived and wrote far from her undiscovered country. Time was the one thing she did not have.

But the dead writer enters the unconscious of her contemporaries. She continues to derange and disturb. She is the ghost-writer in all our texts. In Woolf's case, Mansfield entered her dreams. 'I dream of her often – now that's an odd reflection – how one's relation with a person seems to be continued after death in dreams, and with some odd reality too.'[15] Woolf lived on for twenty-one years after Mansfield's death. She had her best work before her.

Even after their vicious quarrels and Lawrence's unpardonable, cruel letters Mansfield continued to read Lawrence's writing and continued to argue with him indirectly, in her reviews, journals and letters. She loathed *The Lost Girl* (1920) and admired *Aaron's Rod* (1921). In July 1922 she wrote, 'He is the only living writer whom I really profoundly care for. It seems to me whatever he writes, no matter how much one may "disagree", is important,'[16] and a month later, in August 1922, she wrote, ' But I feel nearer L. than anyone else. All these last months I have thought as he does about many things.'[17] When Lawrence and Frieda heard of Mansfield's death, Lawrence buried all the old animosities and tensions and wrote to Murray.

Yes, I always knew a bond in my heart. Feel a fear where the bond is broken now. Feel as if the old moorings were breaking all ... I asked Seltzer to send you *Fantasia of the Unconscious.* I wanted Katherine to read it. She'll know, though. The dead don't die. They look on and help.[18]

Lawrence needed Katherine to be there still, as his reader. But Lawrence himself was beyond help. The same tuberculosis, the existence of which he and Mansfield had so savagely denied, killed him seven years later in March 1930. Lawrence was only three years older than Mansfield, but few commentators on his work are tormented by regrets that he died so young. We do not feel that Lawrence left important work unfinished. In fact, received opinion seems to be of one voice. His late works, *The Plumed Serpent* (1926) and *The Woman Who Rode Away* (1928), are both symptomatic of his alarmingly fascist political views and his murderous misogyny. His best work, so it is generally said, was already written.

Yet we cannot know this any more than we can be certain that Mansfield's writing would have flourished and evolved between the wars. But in one sense Lawrence is right. The dead don't die. They look on and help. Mansfield has done just that. Christopher Isherwood acknowledged that the heroine of his novel *The World in the Evening* (1953) was based on Mansfield and maintained that she was the source for the opening of *Goodbye to Berlin* (1939) – 'I am a camera' is attributed to Mansfield. In 2004, C.K. Stead, a fellow New Zealander and scholar of modernism, has written part of her story as fiction: *Mansfield: A Novel.* Feminism has changed the ways in which we read women's lives and the significance we accord to them. There have been three major biographies of Katherine Mansfield in the last thirty years. This woman's peculiarly modern, brief life with all its moral ambiguities, selfish demands, savage struggle with terminal illness and terrible sadness, was nevertheless the furnace in which she made her writing, the writing that was her gift to her contemporaries and to us. That writing was the central preoccupation of her life; nothing else mattered so much. And it is still here, still ours, still read.

Notes

1 *Letters,* 1, 80 (August 1917), cited in Meyers, p.137.
2 Leonard Woolf, *Beginning Again 1911–1918* (London, 1964), p.204.
3 See especially *The Fox* and *The Prussian Officer*; also the chapter on lesbian passion in *The Rainbow* and the censored sections of *Women in Love.*
4 Tomalin, p.204.
5 *Collected Stories,* pp.197–8.
6 Ibid., p.201.
7 Ibid., p.261.
8 Ibid., p.261.

9 Meyers, p.127.
10 'Prelude', *Collected Stories*, p.15. The headless duck appears again in Hemingway's *Death in the Afternoon* in the miraculous prose love song to Spain that concludes the book. 'IT' reappears in a novel of the same title by Stephen King.
11 'At The Bay', *Collected Stories*, p.213.
12 See her short story, 'Bliss', where a predatory bisexual woman causes trouble between a husband and wife. Virginia Woolf disliked this story, which she thought 'cheap'.
13 Meyers, p.173.
14 Tomalin, pp.202–3.
15 Ibid., p.204.
16 Meyers, pp.101–2.
17 Ibid., p.102.
18 Ibid., p.103.

Select Bibliography

Dyer, Geoff, *Out of Sheer Rage: In the shadow of D.H. Lawrence* (Little, Brown and Company, London, 1997)

Mansfield, Katherine, *The Collected Stories* (Penguin Classics, London, 2001)

—, *Journal of Katherine Mansfield*, ed. J. Middleton Murray (Alfred A. Knopf, New York, 1927)

—, *Letters between Katherine Mansfield and John Middleton Murray*, ed. Cherry A. Hankin (New Amsterdam Books, New York, 1988)

Meyers, Jeffrey, *Katherine Mansfield: A Darker View* (1978; Cooper Square Press, London, 2002)

Stead, C.K., *Mansfield: A Novel* (Harvill, London, 2004)

Tomalin, Claire, *Katherine Mansfield: A Secret Life* (Penguin, London, 1988)

KATHERINE MANSFIELD: A CHRONOLOGY

14 October 1888 Kathleen Mansfield Beauchamp (known as Katherine Mansfield) born Wellington, New Zealand.

1904–6 Educated at Queen's College, London, then returns to New Zealand.

1908 Returns to London; love affair with Garnet Trowell.

1909 Marriage to George Bowden; travels to Bavaria where she miscarries Garnet's baby.

1911 Publication of *In A German Pension*; first meeting with John Middleton Murray with whom she lived for six years and married in 1918.

1913 First meeting with D.H. Lawrence.

1916 First meeting with Virginia Woolf.

1918 Publication of *Prelude* with the Hogarth Press and first serious haemorrhage.

1920 Publication of *Bliss and Other Stories*.

1922 Publication of *The Garden Party and Other Stories*.

9 January 1923 Dies of TB at Avon, near Fontainebleau in France.

1923 Publication of *The Dove's Nest and Other Stories*.

1924 Publication of *Something Childish and Other Stories*.

1937 Publication of *Collected Stories of Katherine Mansfield*.

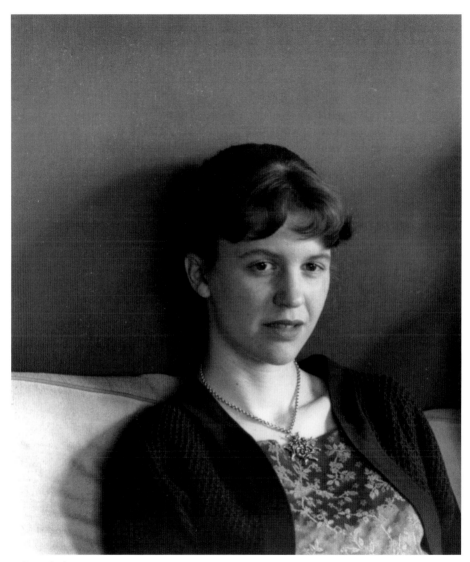

Sylvia Plath, 1932–63
Rollie McKenna, 1959
Vintage bromide print, 254 x 203mm (10 x 8")
Estate of Rollie McKenna

Sylvia Plath

Erica Wagner

Sylvia Plath completed 'Lady Lazarus', her vertiginous poem of death and resurrection as performance, in the last days of October, 1962. 'The peanut-crunching crowd / Shoves in to see / Them unwrap me hand and foot – / The big strip tease.'[1] She was approaching the end of her time at Court Green, the house in Devon she had bought with her husband, Ted Hughes. A year before she had described the place in a letter:

> It is ... very very ancient ... with castle-thick walls in the original back part and almost ten rooms ... The house is white, with a black trim and this primeval peaked thatch. We have just over two acres of land, mostly stinging nettle, but Ted is digging up the big vegetable garden and we'll hope to live on them – he's already put in strawberries, and we have about 70 apple trees ... And blackberries everywhere in season. I have a tiny front lawn carved out of the wilderness – a laburnum tree, lilacs, and a few rose bushes. We adjoin the town church, Anglican, with its own 8 famous bell-ringers.[2]

But now Plath was alone with her children, Frieda and Nicholas, in the big old house. The marriage, which had begun in a blaze of passion and poetry in 1956, was in trouble. Hughes had started an affair with another woman, Assia Wevill; Plath had kicked him out. In the blue solitude of the chill autumn mornings she had begun to write the poems that she knew would make her name.

She could not stay in Devon. That much seems to be apparent in 'Letter in November', completed early in that month, 1962. The poet loves 'the wall of old corpses' – the property was edged by the graveyard – and her seventy trees are

> ... Holding their gold-ruddy balls
> In a thick gray death-soup,
> Their million
> Gold leaves metal and breathless.[3]

In December she closed the house and moved to the flat she had taken in London at 23 Fitzroy Road. It was a house where Yeats had once lived, a house for a great poet. She continued to write: 'Sheep in Fog', 'Totem', 'Words', 'Contusion' – although none of these poems, and none written later, were to be found in the

manuscript for her second book of poems, entitled *Ariel*, which she had collected sometime before she left Court Green.

That winter was very cold. More than half a century had passed since England had seen such weather and – nothing will ever change, it seems – England was not prepared. Sylvia Plath was an American, and a New Englander at that, a girl who'd grown up with snowdrifts and snowploughs to clear them, bitter cold outside but warmth within the walls. London wasn't like that. Snow fell, and piled up and turned to ice. The sky was not high and blue but low and grey. Pipes froze, so there was first no water, and then floods. As Plath wrote, deadpan, in 'Snow Blitz', an account of this big freeze: 'I tried to recall some of the things one cannot do without water beside washing one's face and making tea. There were many.' [4]

'Snow Blitz' conjures a resilient spirit and, up to a point, it was a spirit that Plath embodied. She took her children to the zoo; she planned work she would do for the BBC; she saw friends: Suzette and Helder Macedo, Jillian and Gerry Becker, Al Alvarez. But after Christmas, things were hard. Her novel, *The Bell Jar*, was published under the pseudonym Victoria Lucas and damned with faint praise. American publishers rejected it. At the end of January 1963 she went to see Dr John Horder, the doctor she'd found when she and Hughes had first moved to Primrose Hill three years earlier; she revealed a history of depression, a suicide attempt ten years before. Horder put her on anti-depressants; he tried to find her a hospital bed. Hospital beds, then as now, were hard to find; anti-depressants are slow to work.

Her friends the Beckers looked after her. For a while, at the beginning of February, she stayed with them at their house in Mountfort Crescent, Islington. But on the night of 10 February, a Sunday, she went home with the children; Gerry Becker drove her there, although he felt uneasy about it. Plath, however, was insistent: Frieda would go to playschool the next day; the nurse that Dr Horder had arranged for her would arrive in the morning. So Gerry Becker drove back to Islington, and left Sylvia Plath and her children in Yeats's house in Fitzroy Road.

That night she put her children to bed. Around midnight the poet bought some stamps from her downstairs neighbour; she insisted on paying for them, 'or I won't be right with my conscience before God.' [5] Some time after that – to this day she says she cannot quite recall the sequence of events – she brought bread and milk up to the children's room; she threw the windows wide open, although the night was so cold. She shut their bedroom door and pushed a towel tight underneath as if to make a seal; methodically she taped hinges and cracks. In her clear, round hand she wrote a note: 'Please call Dr Horder'; she pinned it, with his telephone number, to the pram in the hall. Then she went into the kitchen, again shutting a door, this time behind her, again making a seal. It was very late now, or very early, take your pick. She opened the oven door, folded a cloth, laid it inside, turned on the gas. Her

cheek on the cloth inside the oven. The greasy smell of gas waiting for flame and never finding it. Oblivion.

But remember how cold it was. How nothing was working that winter. The cold had made the window frame shrink; carefully Sylvia Plath had shoved it shut, still, it slipped open. And then somewhere, before dawn, a gas main broke; it was lucky no one was hurt. There could so easily have been a terrible explosion, a terrace of houses blown sky high. Enough gas escaped for Plath to be knocked out; much later she would say that she thought she recalled hearing a noise like thunder in the distance. It must have been the nurse, Miss Norris – who had arrived early, despite the terrible weather – forcing open the kitchen door. Norris had become concerned when no one had answered the bell; a local builder, a Mr Langridge, had let her in. Myra Norris knew Plath had had a bad bout of the flu; at first she didn't register the opened oven door, the gas knobs turned full on: she presumed Plath's collapse was related to her recent illness. It was only when she saw how the children's room had been carefully sealed that she realised what Plath had been trying to do. She called Dr Horder. Dr Horder came. By that time, Plath was just conscious; an ambulance was waiting outside. The freeze had made the London streets as quiet as a Sunday that Monday morning, 11 February, and as Sylvia Plath was taken, breathing, alive, to hospital, the siren's wail broke the silence like a shattering of glass.

Before we take this fiction any further, we should stop and take a look at what we are doing, reader and writer complicit together. As we begin to venture into Plath's (real or imagined) life, we must ask: who did Plath mean by the 'peanut-crunching crowd'? Did she mean *me*, sitting here, reading? Did she mean me – the author, writing? What does it mean to approach Plath's work and her life?

I think we have to ask these questions before we continue to imagine a future for a Sylvia Plath who survived that freezing February night. This series of lectures – the intriguing, problematic brainchild of the Poet Laureate, Andrew Motion – is called 'Interrupted Lives' and so, I have been asked to imagine a future for Sylvia Plath, an imaginary future set beyond the night of her actual death, by suicide, in 1963. Yet first – without special pleading, of course – I'd like to discuss the problems that surround this endeavour in particular regard to Sylvia Plath. I'll also run a quick refresher on the facts of her life as she truly lived it. Only then, I think, can we return to the possibilities of the life she never lived; so you'll have to put up with a little bit of backing and forthing.

Sylvia Plath was born in Boston on 27 October 1932, the daughter of Otto Emil Plath and Aurelia Schober Plath. Her younger brother, Warren, was born in 1935. Her father was a scientist, an authority on bumblebees; her mother raised the children until Otto Plath's untimely death in 1940, after which time Aurelia

returned to teaching. Sylvia Plath was raised in a hard-working immigrant culture: she aimed to excel, and she did. She was a straight-A student and popular with boys; the latter a crucial amelioration to the former. She went to Smith College, Boston, on a scholarship and here too she excelled – although folded into that excellence was a suicide attempt in 1953 and a period spent at McLean Hospital in Belmont, the psychiatric institution where both the poets Robert Lowell and Anne Sexton would be treated. But she had already begun to be published: a short story, 'Sunday at the Mintons', won a contest in *Mademoiselle* magazine in 1952 and a prize of $500. Another win was that of a Fulbright Scholarship to Cambridge.

She arrived in England in the autumn of 1955; in February of 1956, at a party, she met Ted Hughes. In June of that year they married. Theirs was a remarkable literary partnership that lasted nearly seven years. Before her death at thirty, Sylvia Plath had published two books: *The Colossus* (1960), a volume of poems, and *The Bell Jar* (1963), an autobiographical novel – 'a potboiler' she called it – which appeared under the pseudonym Victoria Lucas. Towards the end of her life she began to write the poems of *Ariel* – a second volume published two years after her death by Ted Hughes, her literary executor. She knew what she was up to. Five months before she took her own life she wrote to her mother of the new life she was making, separate from Hughes: 'I am a writer ... I am a genius of a writer; I have it in me. I am writing the best poems of my life; they will make my name.'[6] She was right. But that February morning in 1963 she was not found alive. She had worked hard and done well. She was dead. Those are the facts as we have them.

Plath is unique among the writers in this series of 'interrupted lives' – Shelley, Edward Thomas, Christopher Marlowe, Angela Carter and Katherine Mansfield – unique for two quite separate reasons. The first is that, since her death, to this day, a pitched battle has been fought for possession of her, for the right to speak for her. She is a writer with a strong – sometimes almost unbearably strong – voice and yet, to her readers' discomfort, she has always needed to be spoken for. In February 1963 she was barely known as an artist, although she'd had her work published and even had a coveted 'first reading' contract with *The New Yorker* magazine – though Howard Moss had a habit of turning down what she sent him. She was, however, the wife of a famous poet: Ted Hughes's first book of poems, *The Hawk in the Rain*, had been published in 1957; *Lupercal* followed in 1960. The first won the Somerset Maugham Award; the second the Hawthornden Prize; Hughes was not yet thirty and was already a powerful figure in the British literary landscape. He believed that his wife was an artist of remarkable gifts, but few others were truly aware of the extent of those gifts. After 1963 – because he and Plath had never divorced – he became the medium through which she might speak. Through his agency the forty poems of *Ariel* were published in 1965, although they were not the same poems that

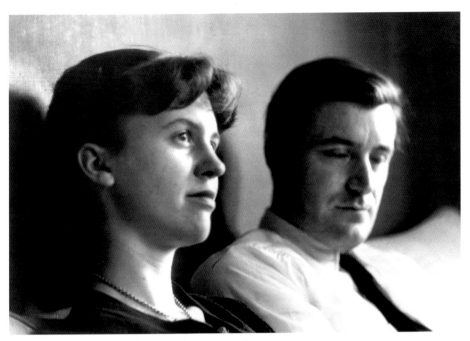

Sylvia Plath, 1932–63, and **Ted Hughes**, 1930–98
Rollie McKenna, 1959
Vintage bromide print, 202 x 253mm (8 x 10")
Estate of Rollie McKenna

Plath herself had originally chosen. The book was reviewed in *Time* magazine when it appeared in America in 1966; the reviewer called the poet 'a literary dragon who in the last months of her life breathed a burning river of bale across the literary landscape'.[7] Ted Hughes saw to it, too, that her short fiction and essays – work that meant much to her – finally saw the light of day: a collection of prose pieces, *Johnny Panic and the Bible of Dreams*, was published in 1977. *The Collected Poems*, edited by Hughes, appeared in 1981 and won a Pulitzer Prize. Her journals were also published, and a volume entitled *Letters Home* – her correspondence with her mother, Aurelia Plath. 'Everybody knew everything,'[8] Plath once wrote in her journal, recounting a dream in which the details of her life were exposed to a hostile crowd. It was a line echoed exactly by Ted Hughes in his poem, 'The God', at the end of *Birthday Letters*, his last book of poems, a work addressed to his dead wife.[9]

But it was not enough, what we were given. How was it possible to reconcile all the voices now arising, each one the voice of Sylvia Plath? The crystalline, Delphic, rage-filled voice of her poetry; the slangy, knowing kick of her prose; the brittle

brightness of her letters, the pain of her journals? Who was she? Who was she *really*? Readers knew that there must be secrets – Hughes had, for instance, perhaps unwisely revealed that he had destroyed a volume of her journals; another volume had 'disappeared'.[10] Over the years, under Hughes's presumed stewardship, other material vanished; at the time she and Hughes separated she was working on a novel entitled 'Double Exposure' or 'Doubletake'; Olwyn Hughes, the poet's sister, mentions it in a letter to Plath's mother in 1968.[11] In the introduction to *Johnny Panic*, Hughes remarks that 'After *The Bell Jar* she typed some 130 pages of another novel, provisionally entitled *Double Exposure*. That manuscript disappeared somewhere around 1970.'[12] In 1995 he told Drue Heinz in the *Paris Review* that there had been only sixty or seventy pages of this book – and that he had assumed that Aurelia Plath had taken them on one of her visits.[13]

Out of paradox and secrecy come stories. And the story of Sylvia Plath became the story of the woman, not the artist. 'I hope each of us owns the facts of her or his own life,' Ted Hughes wrote in a letter to a newspaper in 1989.[14] Of course we don't. They slip away from us, they refuse to be called facts in the first place, they take on a life of their own. So Sylvia Plath, who spoke loud and clear and yet needed to be spoken for, began to be ventriloquised, fictionalised. There were novels – Emma Tennant's *The Ballad of Sylvia and Ted*; *Wintering* by Kate Moses. You might have noticed there's been a film, too, entitled simply *Sylvia*, which for copyright reasons has had to dispense with poetry altogether, leaving audiences a melodramatic love story with a bitter end. Peanut-crunchers? Why not popcorn instead?

And yet, four decades on, the work continues to draw us in. If Sylvia Plath had lived – had been resurrected not just the once but for a second time – what would have become of her life? What would have become of her art? What would have become of our perceptions of her? What would have become of our perceptions of those whose lives she touched?

Now we may depart from the facts. 'Alembic', a poem published in *The New Yorker* early in 1967 – by which time Plath was living in Manhattan – hints at the transformation undergone that freezing spring. In part its imagery marks a return to the chilly pallor of earlier poems, echoing the hospital colours of 'In Plaster' or 'Tulips'. Yet there is a change from the iron coldness, the relentless inward gaze of the earlier work. The 'queer alchemy' of a poem like 'Eavesdropper' has itself undergone some alchemical process, as the title reveals. The speaking voice of the poem moves between the vessel described and the substance within: a kind of rebirth, it would seem, had occurred.

By then, of course, *Ariel* had been published. Certainly, when it appeared in 1964, on both sides of the Atlantic, it had been noted. Yet it had not been

universally praised. The *New York Times* remarked that 'while there is much to be admired in this poet's second volume – not least her relinquishing the formal constraints that too closely bound her first – some of the work could easily be called shrill. The present mood sets high store by feminine hysteria; but present moods can be passing fashions.' It was not reviewed in *Time* magazine.

When Plath sold some of her papers and books to her Alma Mater, Smith College, in 1985, a first edition of Betty Friedan's *The Feminine Mystique* was included in the collection. Plath, one may imagine, allowed herself a wry smile when she re-read therein part of the address that Adlai Stevenson, Governor of Illinois, had given to her own graduating class: women's political job is to

> inspire in her home a vision of the meaning of life and freedom ... to help her husband find values that will give purpose to his specialized daily chores ... to teach her children the uniqueness of each individual human being. This assignment for you, as wives and mothers, you can do in the living room with a baby in your lap or in the kitchen with a can opener in your hand. If you're clever, maybe you can even practice your saving arts on that unsuspecting man while he's watching television. I think there is much you can do about our crisis in the humble role of housewife. I could wish you no better vocation than that.[15]

In 1955 Plath had listened rapt; in 1963 that particular dream had lost some of its sheen. 'We were like Alice in Wonderland,' she wrote years later in a letter to the Canadian novelist Carol Shields. 'We just drank it down, like wine, all that stuff. We didn't know it would make us shrink.'

By the time of *Ariel*'s publication, Plath had moved back to Boston. Her mother, Aurelia, had persuaded her that this would be for the best. Mrs Plath believed that it was her daughter's isolation in England – a stranger in a strange land – that had driven her to the edge; Aurelia had been present for the bitter scenes that had marked Ted Hughes's departure from Court Green in 1962. Hughes tried to dissuade her, but to no avail. 'She would not budge,' he wrote in a letter to their Cambridge friend, Lucas Myers. 'When I saw her in the hospital, it was like something had been emptied out of her; but something had filled her too. She had a steadiness, even though she was weak; it had always been there, of course, like a light, but now it was very clear. There was nothing I could do. I tried.' He was concerned that he would lose touch with his children; he was always assiduous, over the years, in travelling to visit them as they moved, with their mother, from Boston, to New York, for a while to California; these parental visits too were in part responsible for the growth of his own poetic reputation in the United States.

Sylvia Plath needed to support herself. For a while she stayed, along with the children, in her mother's home in Wellesley, but the arrangement was hardly satisfactory. 'Mother is wonderful with the children,' she wrote to her friend Ruth Fainlight, back in England. 'But I know now how much I need a space of my own. I am looking for an apartment! Right in Boston, I think. Ted has been good about money, and mother too. But I need to do this for myself. I know what I can do.' Not long after she and Ted had married, they had had a spell in America; Plath had taught at Smith. It had not been the happiest of experiences for her – yet now she thought she might return. It would be a start. She had made a clean break with her old life, and now, in any case, she was a woman with a book of poems to her name, and a novel; she was not, as she had been before, simply an ex-student returned to her old stamping ground. 'She was an amazing teacher,' recalled one of her students – the newspaper columnist Molly Ivens, as it happens, who graduated from Smith in 1966 and has lately been the scourge of George W. Bush. 'Sometimes we'd go back to her apartment; she'd painted the ceiling sky-blue, I always remember that. She made us laugh! She was funny, she was smart. You couldn't get anything past her. She made you love your work.' Ted came over to see her, and the children; in the summer of 1964 she took them to England and stayed back at Court Green. He lived alone there now, in that big house; Assia Wevill had returned to her husband David after Plath's suicide attempt. Plath and Hughes divorced; but she seemed to be able to let go of her rage and find a way to be with him, for the children's sake, amicably.

If she was happy at Smith, then why did she leave? One answer would be the achievement of a long-held dream: she would get a PhD in psychology; she would move to New York to do so, at Barnard. In Boston she'd reconnected with Anne Sexton, but now she told her: 'I'm always looking for home and it always stifles me. I used to think writing, writing, writing was the only way. It was what Ted thought; it was what we did. But I'm too interested in the rest of the world now just to keep my head bent over the page.' But perhaps the break with her mother had something to do with it. Plath admitted that she had tried to keep her mother from reading *The Bell Jar* – which did not find an American publisher – but it seems she did not succeed. 'The room blued into view,' her mother read, 'and I wondered where the night had gone. My mother turned from a foggy log into a slumbering, middle-aged woman, her mouth slightly open and a snore ravelling her throat. The piggish noise irritated me, and for a while it seemed to me that the only way to stop it would be to take the column of skin and sinew from which it rose and twist it to silence between my hands.'[16] Now Esther Greenwood, the novel's heroine, was not Sylvia Plath; but certainly the events that the novel depicted were close enough to the actual events of the writer's early life to cause her mother distress.

And more would follow. When she moved to New York in the late summer of 1967, to an apartment in Morningside Heights, not far from Barnard, she took with her the manuscript of *Double Exposure*, the novel she'd been working on when she left England. She continued to write, despite the pressures of her academic work, the teaching she'd taken on at the New School to support herself, and a hectic schedule of childcare which she'd arranged, as she later wrote 'by staring down the Gorgons in the Graduate Assistance office and *making* them help me.' *Double Exposure* was published – by Alfred A. Knopf – late in 1968, the year that saw the publication of Gore Vidal's *Myra Breckenridge* and John Updike's *Couples*. It was a year of upheaval, too – in April the campus of Columbia University, with which Barnard is affiliated, was nearly shut down by student unrest. It was also at this time that Plath came to know the poet Denise Levertov; they were allied in their vehement opposition to the war in Vietnam. But *Double Exposure* made the personal political: where the targets of *The Bell Jar* had been found in her early life, now she'd set her cross-hairs, it seemed, on her marriage. Reviewers were ecstatic – perhaps it was a question of timing as much as anything else. 'An excoriating triumph,' said the *New York Times*. 'Bitter, bold and funny, in an awfully ruthless way,' remarked the *Boston Globe*. But not everyone was pleased. Hughes wrote to her from England. 'You've given it all away,' he said. 'Can't you see? It won't belong to you anymore. And that isn't fair to any of us.' Relations between them cooled and stiffened.

And then –

Well, what do you think? I mentioned California. Let's say, her success as a novelist led her to abandon that PhD; she loved the sun, after all, and might have found a life in Berkeley, far from her mother, far from Hughes and close to her rival and later great friend, Adrienne Rich, whom she'd first met when she moved to New York. Prose, you could argue, was her goal, and perhaps that's how she continued to work, in the main, and be remembered, her books thought of alongside those of Joyce Carol Oates, Alison Lurie, Doris Lessing, Muriel Spark. Perhaps her vivid, mythic imagery developed further and led her back towards epic and fairy tale; we imagine Angela Carter reading Plath; we imagine Plath reading Angela Carter. What would have happened then? That poem I invented, 'Alembic', was it published in a third collection? Was there a fourth? Or what if she'd stayed in New York, finished her PhD, let the fuss around *Double Exposure* die down? She became particularly interested, perhaps, in the treatment of manic depression, a condition she felt she understood well. She built a practice. She turned her great, creative energies towards others. She met a good man – not a writer. A doctor; she might have recalled her youthful, clandestine visits to a hospital with a boyfriend who was a medical student. Now she was older, wiser, happier. What then?

But these dangling possibilities bring us to the other respect in which Sylvia Plath, at least in so far as this series of talks is concerned, is unique. All our lives, of course, are in some way 'interrupted'; but Plath's was interrupted in a very particular way. She chose to end it. And she chose, furthermore, to address that choice in her work. What would it mean to read a poem like 'Edge' – perhaps the last poem she ever wrote – without the knowledge of the event that followed its writing? However much we wish to separate the biography from the work, the work arises from a body, from a heart, from a mind. 'The woman is perfected. / Her dead / Body wears the smile of accomplishment.'[17] It was her death, and the manner of it, that transformed Plath into the icon that has threatened to overtake her work. No one has made a movie about Adrienne Rich. In 'The Shot', a poem in *Birthday Letters*, Ted Hughes appears to view her life moving in a trajectory towards death; well, that could be said of all of our lives, or it may be going too far. Still, it must be said that while Plath's work is brilliant, it is a sealed-off, airless brilliance. It leads us, as far as we can go, down a dead end. It led Plath there too.

There is one other thing, before we end. It is as well to consider what we would not have, if Plath had lived. Why do we know her so well, feel, indeed, that we are entitled to her? Why, because we can read just about every scrap of her writing – not only her poems, her novel, her stories, but her private journals and her letters to her mother, too. If she were still alive – or if she had died but paid more careful attention to the fate of her papers – we might not have any of that, not know any of what we know, much of it intensely private information. Without all these secrets laid out for us we would be far less curious for more. We wouldn't know there were any secrets to share.

Imagine, too, if she had not died at the time and in the manner she did, what would have become of Ted Hughes? He once wrote to Plath's mother that his wife's death 'threw my whole nature negative' and brought disaster on anyone close to him.[18] In 1969 Assia Wevill committed suicide using the same method as Plath; Shura, her little daughter, died too, alongside her. Would both of those deaths have occurred if Plath's had not? It seems probable that they would not have. What of Hughes's work? *Crow* was published in 1970. One of its poems, 'Examination at the Womb-door', begins:

Who owns these scrawny little feet? *Death.*
Who owns this bristly scorched-looking face? *Death.*
Who owns these still working lungs? *Death.*[19]

Gaudete, a strange, extraordinary book, was published in 1977; in it the Reverend Nicholas Lumb is swept into the underworld while his doppelgänger, cut out of an

oak tree, organises the women of his parish into a kind of sexual coven; Lumb's double is eventually murdered. Near the end of his life Hughes translated Euripedes' *Alcestis*, the tale of a king who allows his wife to die in his stead. As ever, it is dangerous to draw the threads of work and life too close; they can never be woven into good yarn. Yet surely, without the wounds circumstance inflicted upon him, Hughes's work would have taken a different turn. Surely he would not have been viewed, and indeed viewed himself, as the towering but shadowed figure we are left with now. And it goes without saying that there would have been no *Birthday Letters*, nor its companion volume, *Howls and Whispers*, its existence revealed in the *Collected Poems* published in 2003. Incidentally, we may see in those two books that Hughes had already imagined Plath's 'interrupted life'. The poem 'Freedom of Speech' imagines Plath at her sixtieth birthday, 'in the cake's glow', surrounded by 'your court of brilliant minds ... Their eyes creased in delighted laughter ... Only you and I do not smile.'[20] In another poem, 'The Offers', she haunts him: he sees her on the Tube; in her home; she sends him, after her death, a postcard from Hawaii. She enjoins him not to fail her.[21]

I think that he did not fail her. Ted Hughes once wrote – he really did – to his friend Keith Sagar that after her death he had turned to the myth of Orpheus but then rejected it as 'too obvious an attempt to exploit my situation'. Still, he could not get away from it. He continued: 'The shock twist was that Pluto answered: "No, of course you can't have her back. She's dead, you idiot."'[22]

And yet, she is not. Not because I have resurrected her here, in fantasy, but because her work flies forward, into the future.

Notes

1 Sylvia Plath, *Collected Poems* (London, 1988), p.244.

2 Plath to Helga Huws, in Anne Stevenson, *Bitter Fame* (London, 1998), p.222.

3 Plath, *Collected Poems*, p.253.

4 'Snow Blitz', in *Johnny Panic and the Bible of Dreams* (London, 1979), p.129.

5 *Bitter Fame*, p.296.

6 Sylvia Plath, *Letters Home*, ed. Aurelia Schober Plath (London, 1978), p.468.

7 *Time* magazine, 10 June 1966, quoted in Jacqueline Rose, *The Haunting of Sylvia Plath* (London, 1997), p.223.

8 Karen V. Kukil (ed.), *The Journals of Sylvia Plath* (London, 2000), p.432.

9 Ted Hughes, *Collected Poems* (London, 2003), p.1163.

10 Paul Alexander (ed.), *Ariel Ascending: Writings About Sylvia Plath* (New York, 1985), p.152.

11 Diane Middlebrook, *Her Husband: Hughes and Plath – A Marriage* (New York, 2003), p.237.

12 *Johnny Panic*, p.11.

13 Middlebrook, op. cit., p.237.

14 Quoted in Janet Malcolm, *The Silent Woman* (London, 1995), p.8.

15 Quoted in Betty Friedan, *The Feminine Mystique* (London, 1963), pp.60–61.

16 *The Bell Jar* (New York, 1981), p.101.

17 Plath, *Collected Poems*, p.272.

18 Middlebrook, op. cit., p.234.

19 Hughes, *Collected Poems*, p.218.

20 Ibid., p.1166.

21 Ibid., p.1180.

22 Christina Patterson, 'Ted on Sylvia, for the record', *Guardian*, 18 August 2001.

SYLVIA PLATH: A CHRONOLOGY

27 October 1932 Born in Boston to Aurelia Schober Plath and Otto Emil Plath.

27 April 1935 Birth of brother Warren.

5 November 1940 Death of Otto Plath, following complications from diabetes.

Summer 1950 Graduates from Bradford Senior High School in Wellesley, Massachusetts; in September, she arrives as a freshman at Smith College.

August 1953 First suicide attempt. Undergoes electroconvulsive therapy at McLean Hospital outside Boston.

May 1955 Awarded Fulbright Scholarship to study in Cambridge, England; later that summer, graduates from Smith summa cum laude.

Autumn 1955 Arrives in Cambridge.

February 1956 Meets Ted Hughes at a party for a literary magazine, *St Botolph's Review*.

16 June 1956 Ted Hughes and Sylvia Plath are married at the church of St George the Martyr, Bloomsbury.

Autumn 1957 Moves to Northampton, Massachusetts, with Hughes; begins teaching freshman English at Smith.

25 June 1958 First acceptance of poems by *The New Yorker*: 'Mussel Hunter at Rock Harbor' and 'Hardcastle Crags'.

January 1959 Begins auditing Robert Lowell's writing seminar at Boston University, along with Anne Sexton and George Starbuck.

January 1960 The Hugheses arrive back in London to look for a flat; in February move in to 3 Chalcot Square, Primrose Hill.

10 February 1960 Signs contract with William Heinemann for publication of her first book of poems, *The Colossus*.

1 April 1960 Birth of Frieda Rebecca Hughes.

October 1960 Publication of *The Colossus and Other Poems*.

February 1961 Offered a 'first reading' contract for her poems with *The New Yorker*.

May 1961 Alfred A. Knopf to publish *The Colossus* in the United States.

August 1961 Moves to Court Green, in Devon.

October 1961 Heinemann agrees to publish her novel *The Bell Jar*; in November wins a Eugene Saxton Grant, worth $2,000, to write prose fiction over the year.

17 January 1962 Birth of Nicholas Farrar Hughes.

September to early December 1962 The poems of *Ariel* composed.

December 1962 Moves to London, alone, to 23 Fitzroy Road.

January 1963 *The Bell Jar* published, under the pseudonym Victoria Lucas.

11 February 1963 Sylvia Plath pronounced dead in her flat in Primrose Hill. The coroner's verdict: 'did kill herself'.

Ariel was first published in 1965. Sylvia Plath's *Collected Poems* were published in 1981 and won a Pulitzer Prize the following year.

Angela Carter, 1940–92
Mike Laye, 1989
Fujia Provia 100ASA E6 transparency film, 60 x 70mm (2⅜ x 2¾")
Mike Laye

Get Carter

Ali Smith

In 1989 the photographer Mike Laye came to Angela Carter's house in Clapham to take her photo for an article about prominent Londoners for an Italian magazine. Carter was, he remembers, 'quite surprised that anybody in Italy would be interested in seeing a portrait of her.' He was a little worried about taking the photograph. 'This tendency to distrust the image I have found more common among writers and those who work with words than others, more common among women than among men and more common among feminist women faced with a male photographer. So, as you can imagine, I approached photographing a high-profile, feminist, female writer with some trepidation!' Carter, he found to his relief, was 'a delight – lively, intelligent, amusing and charming, unassuming without any "attitude" at all.' In the end the article never ran but the picture did get picked up by the British media in some of the publicity for Carter's *Wise Children*, and after her death three years later it became one of the most prepossessing images of her.

There she is. She's in her late forties, sitting at her desk in her study, wry but not at all unhappy-looking, momentarily interrupted at her work, with the London skyline light blue behind her and the debris of a working life messily strewn all round her on the floor – the books, the music, the pictures, the pages, most noticeably the two huge wastepaper baskets full of screwed-up paper that overflows round her feet as if she rises up out of it, her and her typewriter with the neat pile of manuscript pages balanced on top of it, the work done. It's a classic picture of the artist *in situ*, the writer caught naturally in the middle of things, by chance as it were, by the photographer who just happened to walk in and catch her.

But get the 'real' Carter?

She told me that I would find her study remarkably tidy, as normally it was a complete mess but she had had it tidied in case I wanted to photograph her there. This room was really the only place in the house that seemed right. My assistant and I set to, emptying the waste-paper bin and scattering the contents over the floor, then adding books and records that had been nicely racked, into piles on the floor! She was pretty shocked at what we had done to her once-tidy study but did confirm that we had returned it to pretty much its usual state!

I imagine she'd have loved this workaday transformation into the performance of herself as she stepped over the artfully arranged bits of paper. She'd have loved the

layering of it, real over fake over real. Is she fact or is she fiction? She's both. Apparently she very much liked the picture. 'I was so shocked when she died,' Mike Laye says. 'She had seemed such an "alive" kind of person.'

She died in 1992, of lung cancer. She was fifty-one. It wasn't a young-and-tragic writer's death, like Plath's or Brooke's or Keats's, it was the loss of an artist at the height of it, an artist who, from the publication of her strange, dark, savagely comic first novel, *Shadow Dance*, in 1966 when she was just twenty-six, to the life-loving, generous and energetic blast of what turned out to be her last, *Wise Children* in 1991, had always worked at the height of it, and whose power had, each time she wrote, and within the mere twenty-five years in which she wrote, revolutionised the literary and intellectual landscape and made unthinkable heights possible.

Playful, fearless, fierce and brilliant, Carter's work made contemporary critics dizzy. She was surprising and uncategorisable: how annoying. Each of her nine novels redefined this originality and in her three seminal collections of short stories her anarchic fusion of low and high art took to bits the machineries of romanticism, tale-telling, biography, social structure, the notion of story itself, and laid them bare, then transformed them, recreated them. She wrote verse, poetry, stage and radio plays, screenplays; she was a gifted painter, she wrote children's fiction, she edited, translated, rewrote and analysed the fairy tale tradition, she was an exceptional thinker, critic, reviewer and essayist, a transformer of cultural history and cultural potential. 'The world was the same,' as she writes in one story, 'yet absolutely altered.' That's what it's like to read Carter, to recognise what's familiar and real as strange and loaded and exotic, to know that something else is not just possible but actually there, if you know how to look.

She was born in 1940 of a South London mother and a Scottish father – she was always very proud of not being simply English, and of the combination of austerity and houchmagandy her northern roots bequeathed her. She married in haste, at the age of nineteen, to get at her mother, she said, and to not have to stay a reporter on the *Croydon Advertiser* for long (her first job: her father was a journalist and wanted her to work on Fleet Street, but as she put it to her friend Susannah Clapp, who commissioned her to write some of her best non-fiction at the *London Review of Books*, 'I had a little problem with facts ... '). Instead she studied English, specialising in the medieval period, at Bristol University in the early Sixties. She began writing award-winning novels; she travelled to Japan in 1969 on a Somerset Maugham award which allowed her, as she put it, to run away from her husband (she thought Somerset Maugham would have been rather pleased by this), took a lover there, lived there, came back and divorced her husband, started writing stories and novels which were too original to win prizes, settled down with Mark Pearce in Clapham, miles from conventionally fashionable literary North London and, defying both by

nature and by chance the conventional shape of things, stopped dyeing her hair, went completely grey, and then gave birth when she was forty-three to her son, Alexander.

Her influences? Shakespeare, Defoe, Blake, Swift, Poe, Carroll, Melville, Dostoevsky, Mary Shelley, the French Symbolists, the Surrealists, Barthes, Borges, Foucault, Calvino, the eighteenth-century writers, an annoyance at Dickens whom she thought of as a strip-cartoonist and Austen whose mannered charm she found deadly, later an annoyance at Joan Didion, Jean Rhys, all the novelists of 'self-inflicted wounds', as she put it, and later all the novelists who introduced, as a matter of course, cheerful love-a-duck cockney cleaning ladies into their work, which told her, she said, all she needed to know about the way these writers saw the world, and the ladies were called cleaning ladies, as she said to Paul Bailey in a late interview, because of course the whole point was that they weren't ladies at all.

What wasn't an influence? Carter took it all in. She could; she was the product of a transformatory time, and not just of the obvious tranformatory Sixties, themselves the product of the time before them; she was 'the apotheosis of the 1944 Education Act,' part of a generation who 'took further education as a right. We sat down at the table of privilege and − complained about the food.'[1] She particularly loved cinema: 'I like anything that flickers,'[2] she said, and the cinema divas, Mae West, Dietrich, Brooks, Garbo whom she thought remarkably like a man and whose female-impersonating she admired (and fictionalised in *The Passion of New Eve* [1977]). She revered Godard, Buñuel, the makers of *nouvelle vague* new narratives. A love of medieval texts gave her her sense of the emblematic and led her into romance territory, folktale, anthropology, multiplicity of meaning and voice and an appreciation of good rowdy bawdiness. When it came to the moderns, though she was drawn to *Orlando* and adapted it into a script at one point, she always chose James Joyce over Virginia Woolf, for class reasons, and because of his 'magisterial project, that of buggering the English language, the ultimate revenge of the colonialised.' If Joyce had been a singer, as his wife Nora had wanted, Carter says, 'I, for one, as a writer in post-imperialist Britain, would not even have had the possibility of a language.'[3]

She wrote with such an eye to the histories of words and books that she reignited the common English language with itself. The happy dandification in her work never strayed far from the comedy of bombast − as one of the earliest of her unexpectedly raucous old women characters declared in a very early short story, 'THE BOWELS ARE GREAT LEVELLERS'. She made the conservative critics angry with what they took as her humourless postmodern political correctness, she made the feminists angry by being far too funny and politically incorrect. She made the categorisers uneasy by refusing to fit. Paul Bailey asked her about that stickiest

of the labels people like to attach to her, Magical Realism, and she explained she believed Magical Realism couldn't apply to English writing where it made no sense to use it (and although it's radio you can almost hear her eyebrows raise, her eyes roll in a combination of mock and real disgust): 'My friends tell me it's pretty passé in Latin America. It's quite made me want to write a novel about a cleaning lady.'

She was, Clapp says, 'the opposite of a soundbite.' Her actual voice was girlish and sardonic, dripping with humour, a fusion of decorous and blasphemous. She made you wait for the end of a sentence; her speech pattern resembled the thinking process. She was notoriously foulmouthed. At the outbreak of the first Gulf War she left a three-minute message on Clapp's answerphone consisting entirely of fucks. She was a committed socialist, 'the pure product of an advanced, industrialised, post-imperialist country in decline,'[4] one who knew that it's history that makes us, and who believed art is always political (and it's possible to see everything in her work, including her feminism, as a consequence of her socialism; these were the kinds of self-made feminism and socialism that made her declare that if she ever had a daughter she'd call her 'not Simone, not Rosa, but Lulu,' after the protagonist of Wedekind's Lulu plays, played in Pabst's silent classic *Pandora's Box* by the silent film star Louise Brooks, whom she loved, who typified for Carter in life, on film and in her own modern legend, qualities she'd most wish for in a daughter – 'the subversive violence inherent in beauty and a light heart.'[5]

And what's the legend now, about Carter? Was she really so neglected in her time? Did she really go so unrecognised? She was certainly unrecognisable to Selina Scott who, when fronting a Booker Prize television programme in the late Eighties, asked Carter, whom she took for a punter in the audience, which book she thought would win that night. Carter was one of the judges. (She dealt with it decorously, wryly, hilariously.) And on a more anecdotal note: when my friend Sarah Wood wanted to study Carter for an English dissertation at Cambridge even as late as 1988, there was a fuss about whether it would be allowed and about the finding of a tutor. Hardly anybody could do it: not surprising at Cambridge, where they prefer their writers to be dead, and the one rather 'radical' person they did find had to read Carter for the first time. In 1992–3, the year after Carter's death, there were, as Carter's good friend Lorna Sage, whose great critical understanding assured Carter's literary position both before and after her death, pointed out, 'more than 40 applicants wanting to do doctorates on Carter, making her by far the most fashionable 20th century topic.'[6] Death is a great enforcer of reputations. The week she died Virago sold out of all her books and soon after this, the earlier novels, the ones that hadn't seen the light of day since the Sixties, were all back in print.

Pick up any novel by a woman in the early or mid-Sixties, any good-selling typical book of the time, anything, by the new young novelist everyone was talking

about, Margaret Drabble, or the much more baroque Beryl Bainbridge or, say, *Up the Junction* (1963) by Nell Dunn, which opens on a typical Sixties room:

> We stand, the three of us, me, Sylvie and Rube, pressed up against the saloon door, brown ales clutched in our hands. Rube, neck stiff so as not to shake down her beehive, stares sultrily round the packed pub. Sylvie eyes the boy hunched over the mike and shifts her gaze down to her breasts snug in her new pink jumper.

Or the eponymous *L-Shaped Room* (1960) by Lynne Reid Banks, which opened the door on Sixties realism like this:

> There wasn't much to be said for the place, really, but it had a roof over it and a door which locked from the inside, which was all I cared about just then. I didn't even bother to take in the details − they were pretty sordid, but I didn't notice them so they didn't depress me; perhaps because I was already at rock-bottom.

Compare them to this:

> The bar was a mock-up, a forgery, a fake; an ad-man's crazy dream of a Spanish patio, with crusty white walls (as if the publican had economically done them up in leftover sandwiches) on which hung unplayable musical instruments and many bull-fight posters, all blood and bulging bulls' testicles and the arrogant yellow satin buttocks of lithe young men. Nights in a garden of never-never Spain. Yet why, then, the horse-brasses, the ship's bell, the fumed oak? Had they been smuggled in over the mountains, in mule panniers? Dropped coins and metal heels rang a carillon on the green tiles. The heels of her high boots chinked as she came through the door.

It's 1966. We're still in England. But the tone is outlandish, it's rich, over-rich, a revelation of artifice all round, a knowing fakery in both the room and the voice describing it, rhetorical witty questioning, a promised foreignness and savagery, a place of camp potential and even the premonition of a Western shootout as the doomed scarred blonde beauty, Ghislaine, chinks her boots through the door into the Carter-shaped room. This is another England. This is the beginning of Carter's first novel, *Shadow Dance*.

It isn't that Carter isn't a realist. 'I've got nothing against realism,' she said near the end of her life, as if tired of having to explain. 'But there is realism and realism. I mean, the questions that I ask myself, I think they are very much to do with reality.

I would like, I would really like to have had the guts and the energy and so on to be able to write about, you know, people having battles with the DHSS, but I, I haven't. I've done other things. I mean, I'm an arty person, o.k. I write overblown, purple, self-indulgent prose – so fucking what?'[7]

Her early novels are a passionate and intellectual engagement with and analysis of the artifice – rather than the magic, if you like – that makes realism. In these novels she rejects the drabness that realism is mundanely supposed to be. She is drawn to the interestingly grimy: true grime. For the first five novels she counteracts the pretence that realism is dull and foggy with a gaudy celebration of violence and anarchy, a series of more and more disturbing megalomaniacs, mad masters, sexual puppeteers, and reveals an unexpected animal-wild drama in the boarding house or the rented flat. The novels bristle, not with life, but with bristles. Everything is alive with its own, often scary, unexpected otherness. Joseph in *Several Perceptions* (1968) can't live with his parents any more because at home 'there was a tooled leather *TV Times* cover and a brass Dutch girl concealing fire-irons in the hollow of her back. These things seemed wholly threatening; the leather cover was a ravenous mouth smacking brown lips and the Dutch girl must use her little brushes and shovels as cruel weapons since there was no other use for them; the room was heated by electricity.'[8]

Imagine her, the medievalist, in 1960s Bristol, looking through the window of a shop, whether it's the junkshop her protagonist Morris runs in *Shadow Dance* or the place of strange puppet opera in which Melanie, the middle-class girl of *The Magic Toyshop* (1967) finds herself literally robbed of her middle-classness overnight, dropped into a rich resounding travesty of working-class realism (Carter likes this story of the middle-class girl forced into the land of interesting barbarians, and repeats it in a couple of novels). Melanie, waking up to the 'real', is made to enact the age-old Leda story, the rape process, with a clunky puppet swan. Carter was always fascinated by the performance, the puppet-works, the clock-works, 'the idea of simulacra of invented people, of imitation human beings, because, you know, the big question that we have to ask ourselves is how do we know we're not imitation human beings?'[9]

Already Carter knows the humanity in the music-hall sideways-glance and the sheer stenchy sexiness inherent in a word like 'filthy'. Melanie falls for a filthy, sexy, Irish boy, though she wonders what they look like kissing, and wishes she could see it from the outside: 'then it would seem romantic'.[10] The first five novels enact a symbolic psychological theatre, culminating in the suicidal theatrescape that Marianne, the heroine of *Love* (1971) takes for realism. For her, the Sixties world is a weird and fearful place not just because it is, but because she impresses her internal self upon the external world. In other words, she must be mad; she has 'the

capacity for changing the appearance of the real world which is the price paid by those who take too subjective a view of it.'[11] Carter must have relished all the people who picked up this novel expecting a love story, dropping it, aghast, one of the coldest and most cauterising definitions of love as madness with its male and female young-married protagonists whose names bound together, Annabel and Lee, make up Poe's gothic death-heroine.

She later remembered 1968 as the year of her own 'questioning of the nature of my reality as a *woman*. How that social fiction of my "femininity" was created, by means outside my control, and palmed off on me as the real thing ... towards the end of that decade there was a brief period of public philosophical awareness that occurs very occasionally in human history; when, truly, it felt like Year One, that all that was holy was in the process of being profaned.'[12] The first novels are full of wedding dresses, ripped and torn because the girl wearing it has climbed a tree, or turning to dust because the world in which the dress was relevant is a whole post-nuclear holocaust ago, and Carter burns the Magic Toyshop down in the end; the puppeteer god of it, like all the mad bad controlling gods in her early novels, is deposed, and Melanie and her filthy sexy Irish boy, Finn, stand on the edge of a ruined Victorian pleasure-garden like a new Eve and Adam, about to leave, looking at each other 'in a wild surmise.'[13]

Surmise is a word (like another favourite word, 'intransigent') she uses again and again. Surmise is self-conscious imagination, imagination paired with conjecture, with suspicion, with a streetwise, I'm-wise-to-you curiosity. It was Year One. Carter left the old burnt Eden, went to Japan and came back, her friends record, transformed, renewed, at home with herself as a foreigner, at ease with her own otherness. When she came back, she published *The Infernal Desire Machines of Doctor Hoffman* (1972).

Hoffman is Carter's lost classic. Everybody knows now that Carter rewrote fairy tales, wrote about circuses, music-hall cockney starlets with wings. It's the easily acceptable Carter, the writer who takes the small form, the domestic form, the demotic form and juggles it, Carter as the entertaining laureate of girls in spangly tops in the big ring or on the stage. But *Hoffman* is the novel in which, for the first time, the madness or lostness she analyses in the earlier novels transforms fully into a representation of social structure itself as a possible psychosis. Rather than seeing the world as a place with the psychotic self moving, lost, through it, she switches the order – the world becomes the psychosis and the self recognises it.

You can see how visionary a work it is, now, reading it in the virtual age. It's an astounding book, a dramatic leap forward technically and in vision, voice, structure and poise, from the five preceding novels. Its tale of the demonic Dr Hoffman and the mass illusions with which he alters the landscape whenever he chooses, and the

protagonist Desiderio chasing the Doctor's 'daughter', the vanishing beloved, Albertine, through the Proustian then end-of-pier then tribal then Swiftian then Vietnam-like then futuristic mirage landscapes, questions the nature of all 'real' things and opens on itself like a carnivorous flower, a repeated tease of a postponement of sexual climax. It is a new kind of novel, and Carter knew it.

Many take the year 1979 as Carter's *annus mirabilis*, the year she published both *The Sadeian Woman* and *The Bloody Chamber*. Lorna Sage, with great clarity, notes it as the point when finally Carter could be read collusively by her readers, who would now, given the rewrite of the fairy tales and the study of how narratives are always about the uses of power, finally 'get' the Carter project, what she was about. To me her real, miraculous, breakthrough year is 1972, and *Hoffman* this far-too neglected achievement. 'Autobiographically, what happened next,' she said, 'when I realised that there were no limitations to what one could do in fiction, was ... I stopped being able to make a living.'[14] *The Infernal Desire Machines of Doctor Hoffman* marked, she said, 'the beginning of my obscurity. I went from being a very promising young writer to being ignored.[15]

As she famously noted, she was 'in the demythologising business,' and her business involved 'putting new wine into old bottles, especially if the pressure of the new wine makes the old bottles explode.'[16] The establishment never likes having its wine-cellars raided.

This is probably the place to let them all roll out, the whole recognisable circus of academic Carter themes, somersaulting into this essay like a troupe of acrobats (and don't go thinking this is a cute simile because if you know Carter's writing you'll know that her acrobatic troupes have a surprising predilection for a spot of multiple male rape when they see the chance and the right boy-ingenue). Art, high and low (the switched-at-birth twins of her œuvre). Artifice, and all who sail in her. Britishness, carnival, cinema, class. Clockwork mechanism and timeless human story. Englishness. Fear and its antidote, laughter. Feminism, folklore, language. The mother. Myth. Performance, politics, power and who has it, and how to get it. Profanity and its uses. Real and fake, and their closeness to one another. Sex, social anthropology, theatre, transformation. The woods.

For instance, if you went down to the woods today with Angela Carter, she'd show you that the fairies in among the flowers are all sneezing, they all have phlegmy colds − this is an English wood, after all, and look again, because the woods, she'll show you, are a construct, a death trap gimcrack Hollywood set, like they are in *Wise Children*'s energised and irreverent reconstruction of *A Midsummer Night's Dream*. Carter knew the source of the word 'wood', medievally 'mad', she knew the closeness of carnival to carnivore, she always looked to the sources of things. Her theoretical treatment of the mother, especially through her study of

Angela Carter, 1940–92
Fay Godwin, 1976
Bromide print, 201 x 253mm (7 7/8 x 10")
National Portrait Gallery, London (NPG x68237)

Sade for the 1979 book *The Sadeian Woman*, left feminist critics aghast and offended. Her own feminism in the mid-Seventies took the form of joining the editorial committee of a brand new idea in publishing called Virago, because she was moved, as she wrote to Lorna Sage, 'by the desire that no daughter of mine should ever be in a position to be able to write BY GRAND CENTRAL STATION I SAT DOWN AND WEPT, exquisite prose though it might contain. BY GRAND CENTRAL STATION I TORE OFF HIS BALLS would be more like it, I should hope.'[17]

The mid-Seventies is also when she began writing her cultural and literary journalism, which has never really been granted the critical attention it deserves. Susannah Clapp remembers how, after 1979, 'being in opposition to Thatcher gave us a conciseness. Unimaginable in 1979 that the Labour party would ever be in power again.' Here's Carter on the theatre of Thatcher: 'Gods knows, there've been sufficient pompous windbags at the helm of this nation before, but never one who's combined a script straight out of *The Boys' Own Paper* circa 1909 with the articulation

of Benny Hill *en travestie*. And got away with it. That's the grievous thing.'[18] Here's
Carter on Blake's 'Tyger' (in a piece brilliantly, Carteresquely, entitled 'Little Lamb,
Get Lost'): 'I wonder if Blake had ever actually seen a live tiger. The fusby beast that
illustrates "Tyger, Tyger" in the *Songs of Experience* looks as if he should have a zipper
down his back and a pair of pyjamas inside him.'[19] Here she is on *The Great Gatsby*:
'a soft-edged production, in no way intellectually demanding: you lie back and have
it done to you.'[20] She noted the pornographic way food was photographed for the
UK Sunday papers at the time of the Ethiopian famine and commented on the
powerplay of this, and what nourishment meant culturally. She knew D.H.
Lawrence was 'a stocking man, rather than a leg man' – a lover of drag, of
wardrobes, of 'the narcissistic apparatus of femininity,' who only gets as deep into a
woman's heart as 'the bottom of a hat-box.'[21]

In a seminal essay on Louise Brooks, she describes Brooks's life after her failed
European debut and her return home to the USA, the end of silent cinema and
rejection by the studios, then no money, forgotten stardom, the long, long years in
a gin-soaked obscurity. But then Carter does the switch, swings the hinge. She asks
us to imagine the same thing happening to Marilyn Monroe. Say Monroe, after
Niagara, had been approached by Tarkovsky to play Grushenka in *The Brothers
Karamazov*. Say she went to Moscow and did this, then came home to the USA and
found 'she has gone out of fashion overnight.' She fades away. She lives quietly –
'because I am fond of Marilyn Monroe I will find her congenial work in a children's
home, perhaps. How the children love her!' Decades later, after Glasnost, the film
is rediscovered and cineastes everywhere are blown away by the beautiful blonde in
it. Who is she? 'So, the lovely, fat old lady, resurrected, becomes a staple of film
festivals' and, even better, 'fame has come too late to bewilder or corrupt.'[22]

Marilyn is saved! She lives! An abject end is rewritten and what looks like a
failed life is unmasked as a triumph. Ah, the sheer joy in it, the sheer panache, of
changing the given ending – how to explain the joyousness, the glee, the anti-
mechanistic, Bergsonian laughter and the happy transformations that Carter
disseminates in her later work? The short story form, from her first collection,
Fireworks (1974) onwards, allows Carter to infiltrate story with essay, in other words
narrative with discussion, and to enact, discursively, a new performance of an old
story with this consequence: things don't have to take the shape they've traditionally
been given. The shapes themselves become, instead of given shapes, points of
discussion. But the goodnatured power here, in *The Bloody Chamber* (1979), her most
critically acclaimed work, is in rescuing Red Riding Hood by giving her the fearless
naked sensuality that her hood has masked all this time, in letting Beauty also be a
Beast, in swapping the so-called reality, by an act of artifice, for a better one. So, she
remakes Adam into Eve and God into a many-breasted black diva in *The Passion of*

New Eve (1977). The passive ring-shaped O she talks about in *The Sadeian Woman* (1979), the horrific graffiti-simplicity personifying the enforced passivity of girls and women, she swaps for the circus ring, the theatre – the space where we act – in the final novels. The doomed tragic earlier girls transform into laughing girls who know they're 'nobody's meat', the puppet masters are kissed to death by their own creations-come-alive, and the story simply shifts:

> It must have been as if he had watched his beloved *Tristan* for the twelfth, the thirteenth time and Tristan stirred, then leapt from his bier in the last act, announced in a jaunty aria interposed from Verdi that bygones were bygones, crying over spilt milk did nobody any good and, as for himself, he proposed to live happily ever after.[23]

Here's the ending and, noticeably, it's happy. Cupid is rewritten as a girl, into the flying cockney lightheart, Fevvers, a winged woman soaring above the audience, an artiste, an unlikely aerialiste, 'more like a dray mare than an angel ... not much of the divine about her unless there were gin palaces in heaven where she might preside behind the bar.'[24] A pack of tigers up and dancing to a song, 'waltzing as in a magic ballroom.'[25] 'Hubris, imagination, desire! The blood sang in her veins.'[26] *Nights at the Circus*, her 1984 novel, ends in some very good sex and a huge ecstatic shudder of laughter 'across the entire globe, as if a spontaneous response to the giant comedy that endlessly unfolded beneath it, until everything that lived and breathed, everywhere, was laughing.'[27]

'Is not this whole world an illusion? And yet it fools everybody.'[28] Her last book is an act of synthesis; all the divided selves, the flesh-and-blood people regarding their images and opposites with wild surmise transform into the lifelong syncopation of her *Wise Children*, Dora and Nora Chance, twin high-kicking music-hall hoofers born on the wrong side of the tracks, the illegitimate unacknowledged daughters of a very famous noble English Shakespearian actor. Carter told Paul Bailey, in that late interview, the story of her Aunt Kitty, an alarmingly too-soubrette young thing who, Carter's grandmother thought, might 'go on the halls' but who was forced to become a clerk instead since 'going on the halls' was, Kitty's 1930s education implied, a bit too close to going 'on the streets'. Kitty, she told Bailey, eventually went mad, and died. 'I thought, you know,' she told him, 'I'd send her on the halls.' Another generous resurrection.

Wise Children is her finest novel and her gift of allusive layering and literary lifeforce to the so-called common English voice. The most cheerfully orgiastic and generous and comic and fulfilled of her books, a celebration of birth, life and continuance, a book which makes a point of transforming into an innuendo 'there

he was on the bed, brushing up his Shakespeare,' changing 'What You Will' into 'What? You Will?', a book all about Will, and will, and legacy, and the legacy of entertainment, the joy it is to dance and sing, was in the end her final legacy, her last book.

> But truthfully, these glorious pauses do, sometimes, occur in the discordant but complementary narratives of our lives and if you choose to stop the story there, at such a pause, and refuse to take it any further, then you can call it a happy ending.[29]

Stop.

I spoke to a lot of her friends to be able to write this talk. The dismay on people's faces when they think of her going. 'There was enormous grief when she died. She was much loved,' Fay Godwin, the photographer who took some of Carter's most luminous portrait shots, remembers.

There's a story of her on the phone, waiting for the results of a cancer test and talking to a friend: 'she would talk like anything on the phone, for hours, a full hour,' says Susannah Clapp, 'she was fluent on the phone in this odd, impeded way, almost a physical stop to her sentences, as though she were leaping over a barrier of some sort – anyway she was waiting for the final diagnosis, and someone was just coming up the garden path and she said on the phone – a man's coming up the garden path, oh, wait a minute ... [long pause] oh, it's all right, he hasn't got a scythe over his shoulder.'

Only Carter could demythologise her own death. Only Carter could end a study of de Sade with a proclamation of love. Only Carter could choose as her luxury item on Desert Island Discs – a zebra. Nobody, now, is writing like Carter – by which I mean with her range, her verve, her daring, her formalism and her sourced and clear intelligence. She inspired writers like Jeanette Winterson and Salman Rushdie; Nicola Barker has inherited some of her brio; A.M. Homes, who was taught by Carter in Iowa in the Eighties, has inherited her ability to see how pornographic the world is.

Carter had thought, when she was an adolescent, that she might become an actress. But if Carter had become an actress and not the writer she was, I, for one, know that as a writer in post-imperialist, post-postmodern, post-post-post-feminist Britain, I would not even have had the possibility of a language, never mind the space in which to use it.

She'd have hated New Labour and especially the pseudo-religiosity of Blair. She'd have been furious at the current state tyranny and excited at the biggest mass

political protests in history. She'd have known exactly what to do with the term 'weapons of mass destruction' and exactly what to say to puncture this Age of Sincerity and its smug rhetoric, the 'I believe' performance of politics and culture of now.

What, Susannah Clapp asked her near the end of her life, is the subject which will be most pressing as a general concern in the coming years? Without hesitation, she said 'surveillance.' Had she lived, her friend Margaret Atwood thinks, she'd have gone on from fiction to become one of our foremost cultural, social and political commentators. There is a one-page proposal in her papers for a novel about Jane Eyre's stepdaughter, and a couple of great short stories about Lizzie Borden, who took an axe, seem to suggest that something longer might have come of them. She also had a surefire idea for a prizewinner up her sleeve she said, ha-ha, a book about a philosophy professor and his mistress that covered lots of countries and all the right fashionable ideas, pushed all the right Booker buttons, drank the right wine out of the right bottles, and would, very sonorously, be called *The Owl of Minerva* ... There'd have been a few cheery cleaning ladies in it, presumably.

She looked 'like an angel,' Atwood says, 'she had all this white hair, as if she was all lit up.' Well, let's both mythologise and demythologise: if she was an angel she was a secular one, a knowing one, one with some of the terrifying edge of Rilke's angels; like Benjamin's angel of history whose wings are edged with knifeblades; plus her own Mae West bandy-legged theatrical angel like her flying creation Fevvers: is she fiction? is she fact? – hovering, remarkably lifelike, come laughingly to announce that God is a creation narrative and the world is what we make of it.

'She had trouble with endings,' Lorna Sage said, 'and wanted them to stay open.'[30] Carter is never-ending while we have her own good argumentative interruptive voice, a voice which in the span of one writing life reintroduced buoyancy, thought, shapeshift, unselfishness, politics, richness, risk, originality, timeless new-found story to English writing and made a whole new sense out of the act of writing fiction. Go out tomorrow and get Carter. Get all her fiction, all her fact, read it from its beginning all the way to its glorious open end. Then get down into the wine-cellar and smash open a few of those dusty old bottles. The world will be the same, yet absolutely altered.

Here's to her.

Notes

I spoke to Margaret Atwood in Primrose Hill, London, on Saturday 14 February 2004, Susannah Clapp in Exmouth Market, London, on Saturday 28 February 2004, interviewed Mike Laye by e-mail on Monday 1 March 2004 and Fay Godwin by telephone on Sunday 14 March 2004. Paul Bailey's 1991 BBC Radio 4 interview with Angela Carter was tracked down and provided for me very kindly by Paul himself. Many thanks to them for their kindness and generosity.

1 *Shaking a Leg: Collected Writings by Angela Carter* (London, 1997), p.381.
2 *American Ghosts and Old World Wonders* (London, 1993), p.ix.
3 *Shaking a Leg*, p.538–9.
4 Ibid., p.40.
5 Ibid., p.351.
6 Lorna Sage, *Flesh and the Mirror: Essays on the Art of Angela Carter* (London, 1994), p.3.
7 'Omnibus: Angela Carter's Curious Room', BBC transmission script, 15 September 1992, p.26.
8 *Several Perceptions* (London, 1968), p.24.
9 'Omnibus: Angela Carter's Curious Room', BBC transmission script, 15 September 1992, p.24.
10 *The Magic Toyshop* (London, 1967), p.200.
11 *Love* (London, 1971), p.9.
12 *Shaking a Leg*, p.35.
13 *The Magic Toyshop*, p.200.
14 *Shaking a Leg*, p.35.
15 Interview with Susannah Clapp, *Independent on Sunday*, 9 June 1991.
16 *Shaking a Leg*, pp.37–8.
17 Lorna Sage, *Good As Her Word: Selected Journalism* (London, 1994), p.75.
18 *Shaking a Leg*, p.190.
19 Ibid., p.305.
20 Ibid., p.513.
21 Ibid., pp.500–02.
22 Ibid., p.392.
23 *Burning Your Boats: The Complete Short Stories* (London, 1995), p.142.
24 *Nights at the Circus* (London, 1984), p.12.
25 Ibid., p.164.
26 Ibid., p.291.
27 Ibid., p.295.
28 Ibid., p.16.
29 *Wise Children* (London, 1991), p.227.
30 *Good As Her Word*, p.77.

ANGELA CARTER: A CHRONOLOGY

7 May 1940 Angela Olive Stalker born in Eastbourne, Sussex. Spends the Second World War in Yorkshire and is then educated in Balham, London.

1959 Works as a junior reporter on the *Croydon Advertiser*.

1960 Marries Paul Carter.

1962–5 Reads English, specialising in the medieval period, at the University of Bristol.

1966 Publication of first novel, *Shadow Dance*.

1967 Second novel, *The Magic Toyshop*, published, which wins the John Llewellyn Rhys Prize.

1968 Publication of third novel, *Several Perceptions*, winner of the Somerset Maugham Award.

1969–72 Travels to Japan; lives there for two years. Divorces Carter in 1972 and publishes *The Infernal Desire Machines of Doctor Hoffman*.

1976–8 Arts Council of Great Britain Fellow in Sheffield.

1977 Settles in Clapham, London, with Mark Pearce; joins the editorial committee of Virago.

1979 Publication of *The Sadeian Woman* and *The Bloody Chamber*.

1980–1 Visiting Professor at Brown University, Providence, Rhode Island, USA.

1983 Birth of Alexander Pearce.

1984–7 Teaches part-time at the University of East Anglia, Norwich.

1984 Writer in residence at the University of Adelaide, Australia; *The Company of Wolves* (a film based on *The Bloody Chamber*) is released; *Nights at the Circus* published.

1985 Joint winner of the James Tait Black Memorial Prize for *Nights at the Circus*.

1985–8 Teaches in Austin, Texas; Iowa City, Iowa; and Albany, New York State.

1991 *Wise Children*, her last novel, published.

16 February 1992 Dies.

Picture credits

Locations and lenders are given in the captions, and further acknowledgements are given below.